Seekers and Travellers

Contemporary Art of the Pacific Northwest Coast

GARY WYATT

Douglas & McIntyre
D&M PUBLISHERS INC.
Vancouver/Toronto

University of Washington Press
Seattle

Douglas & McIntyre
An imprint of D&M Publishers Inc.
2323 Quebec Street, Suite 201
Vancouver BC Canada V5T 4S7
www.douglas-mcintyre.com

Cataloguing data available from Library
and Archives Canada
ISBN 978-1-55365-953-2 (pbk.)

Published in the United States of America by
University of Washington Press
P.O. Box 50096
Seattle WA USA 98145-5096
www.washington.edu/uwpress
ISBN 978-0-295-99237-2

Editing by Lucy Kenward
Cover and interior design by Jessica Sullivan
Cover photographs by Kenji Nagai
All photos by Kenji Nagai except
Russell Johnson (pages 55, 119), Jenn Walton (page 73)
and Image This Photographics Inc. (page vi)
Printed and bound in China
by C&C Offset Printing Co., Ltd.

We gratefully acknowledge the financial support of the Canada Council for the Arts, the British Columbia Arts Council, the Province of British Columbia through the Book Publishing Tax Credit and the Government of Canada through the Canada Book Fund for our publishing activities.

Douglas & McIntyre is committed to reducing the consumption of old-growth forests in the books it publishes. This book is one step towards that goal.

Dimensions of works of art are given in imperial, in the order of height × width × depth.

PAGE VI:

I'VE HAD AN ongoing interest in maps since I was a ten-year-old "fisherman" on my grandfather's commercial fish-packing boat, looking at maritime maps that showed the coastline's depths, shoals, reefs, rivers, mountains and islands. I didn't fully grasp the conceptual nature of maps until, as a university student, my summers were spent as a deckhand on commercial fishing boats and I learned to rely on such maps as we navigated the British Columbia coastal waters.

After finishing university, I continued to fish and hunt for food with various relatives, and it was during such a trip that an uncle was trying to teach me the Haisla place names within our boundaries. He used the traditional oral manner, but I forgot the names almost as quickly as they were relayed. When I returned to my artist-in-residency at the University of British Columbia's Museum of Anthropology (MOA), I drew a map that eventually included all the Haisla place names I could gather from Haisla people. This map was the forerunner of the First Nations Map.

My decision to paint a decorative map showing the First Nations language groups of B.C. was also influenced by a frequently asked question about where I was from. My standard reply mentioning my Haisla ancestry was almost inevitably followed by, "I've heard of the Haida." I would then patiently explain the difference between the groups, and I would point out a black-and-white information map on the wall at MOA. Although some visitors remained enthusiastic, a few totally ignored the map. As a visual artist I could relate because I was of the opinion that it was boring and that a decorative map would be better.

Combining the requisite map-making components with serious, integrated and classical PNC imagery was a daunting task that consumed a huge chunk of my time. I "justified" my obsession by telling myself that the map would be useful when someone was looking at my portfolio and could see exactly where we, Haisla, live.

To a lot of people, the completed map remains an oddity because it doesn't fit cognitively with their experience of what constitutes ART. My response is that ART has never been successfully defined to exclude an artist's right to help define it. An underlying political issue of our generation portrayed on the map has escaped detection so far: the linguistic borders are painted in a Morse code sequence that I was told represents the classic distress signal to which all good mariners are obliged to respond: s.o.s!

Contents

Preface

IN 1992 I began a conversation with Douglas & McIntyre publisher Scott McIntyre about a trilogy of books documenting contemporary directions in Northwest Coast art, to be paced about five years apart in order to catch the waves of new artists and concepts emerging in the art form. *Spirit Faces* was published in 1994, and *Mythic Beings* in 1999, but thirteen years have elapsed between that book and this one, the last in the proposed series. It has been an amazing decade.

Great art always meets the challenges of the time, and Northwest Coast artists have responded with great sensitivity to history and tradition and to the obligation to document and comment on current events. In the past ten years, economic, political and environmental events, sometimes involving large-scale calamities, have been frequent and often wide-ranging. The changes in the art form—such as the subjects covered, the materials used and the techniques employed—reflect this rapidly changing world and an escalation in cultural and artistic activity.

Since these books are not catalogues for a specific exhibition, I have been free to choose a cross-section of artists and types of work that I feel best express the contemporary form. Of course, there are many great artists beyond those featured in this collection, but I always try to include a variety of new and established artists—and, whenever possible, to show several pieces by each artist, in order to offer a stronger understanding of personal as well as cultural styles.

In *Spirit Faces*, *Mythic Beings* and now *Seekers and Travellers*, the words describing each piece are those of the artists themselves, which is rare among art books. As usual, I have written an introduction to the book, setting an overall context for the works, but I cannot take credit for the stories or the art. I would, however, like to acknowledge the following people for their support and contributions to this book:

The artists, for their vision and under-standing of the possibilities of Northwest Coast art and for consistently achieving greatness at the highest level;

The many collectors of the art form, locally and internationally, who have made this art part of their personal journey;

The many artists who wrote the text, or sat and worked side by side with me to make the descriptions of each piece their own;

D&M Publishers, for this and past projects and for its overall contribution to the world's recognition of Northwest Coast art, and espe-cially Scott McIntyre and Lucy Kenward, for their efforts to piece together the many ideas that are represented in this book;

The partners and staff of the Spirit Wrestler Gallery—Derek Norton, Nigel Reading, Colin Choi and Eric Soltys—for their integrity and tireless promotion of excellence in the arts; and the extended family—Donna, Judy, Christine and Nicole and Minta—for their support and commitment to our business;

My family—Marianne, Leif, Adrianah, Ellen and Noah—for everything and anything; they are the balance of the work and make it all worthwhile;

Kenji Nagai, for his many years of service as a great photographer and for understanding the power and presence of Northwest Coast objects;

Russell Johnson, for his photos of the glass pieces by Preston Singletary; Jenn Walton and Image This Photographics, for photos of Lyle Wilson's pieces; and Jennifer Webb and the Museum of Anthropology at the University of British Columbia and the Coast Salish Preservation Society for assistance photo-graphing John Marston's piece;

William Wasden, Walter Dejong and Evelyn Thompson, who wrote or assisted with the text for other artists;

The team at the Freda Diesing School of Northwest Coast Art in Terrace, the YVR Art Foundation, Michael Audain and the Vancouver Foundation, the many local and international museums and art galleries that have recognized the contemporary artists and their work and included them in their collections, and the Pilchuck Glass School in Stanwood, Washington, for their tireless support of Northwest Coast art.

This is the end of the trilogy, but it is also a period of growth in Northwest Coast art as a new generation emerges and continues to push the boundaries.

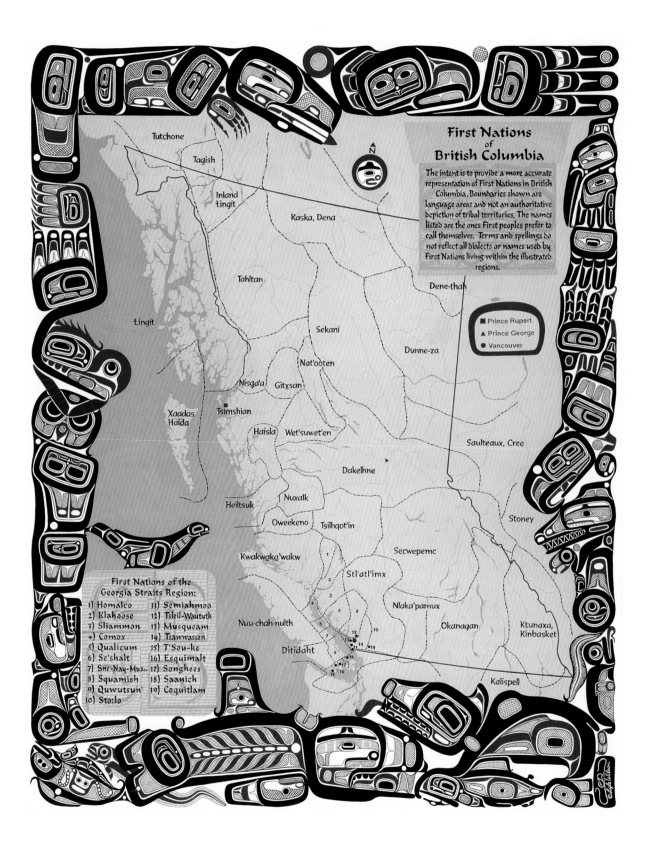

First Nations of British Columbia

The intent is to provide a more accurate representation of First Nations in British Columbia. Boundaries shown are language areas and not an authoritative depiction of tribal territories. The names listed are the ones First peoples prefer to call themselves. Terms and spellings do not reflect all dialects or names used by First Nations living within the illustrated regions.

■ Prince Rupert
▲ Prince George
● Vancouver

Tutchone

Tagish

Inland Łingit

Kaska, Dena

Dene-thah

Tahltan

Łingit

Sekani

Dunne-za

Nat'ooten

Nisga'a Gitxsan

Xaadas Haida

Tsimshian

Haisla Wet'suwet'en

Saulteaux, Cree

Dakelhne

Nuxalk

Heiltsuk

Oweekeno Tsilhqot'in

Stoney

Kwakwaka'wakw

Secwepemc

Stl'atl'imx

Nlaka'pamux

Nuu-chah-nulth

Okanagan

Ktunaxa, Kinbasket

Ditidaht

Kalispell

First Nations of the Georgia Straits Region:

1) Homalco
2) Klahoose
3) Sliammon
4) Comox
5) Qualicum
6) Se'shalt
7) Sne-Nay-Mux
8) Squamish
9) Quwutsun'
10) Sto:lo
11) Semiahmoo
12) Tsleil-Waututh
13) Musqueam
14) Tsawwassen
15) T'Sou-ke
16) Esquimalt
17) Songhees
18) Saanich
19) Coquitlam

Introduction

ART—LIKE LANGUAGE, and ceremonies—preserves deep histories that document the transforming world and record generations of people and their accomplishments. Thousands of stories tell of the natural and supernatural events that have shaped the world, and they tell that recent history has been a time of accelerated change and vanishing resources resulting in permanent losses of cultures, creatures and their habitats. The works of the thirty-six First Nations artists in this collection also showcase the traditional, the cross-cultural and the contemporary. They reveal a reverence for materials such as cedar, ebony and horn, which are disappearing and vital to the continuation of the art. Similarly, they pay respect to the exchange between coastal and neighbouring nations that gave rise to the potlatch ceremonial system and linkages through trade, marriage and warfare. At the same time they reference similarities with geographically distant modern indigenous cultures that share concerns toward language and cultural preservation, environmental programs and artistic innovation. And they celebrate entirely new trends in Northwest Coast art that have been inspired by the traditional and shaped by interactions with other cultures and contemporary artistic practices.

Origins of the Northwest Coast People and Their Art

Fifteen thousand plus years ago, migratory groups began travelling across northern connectors of land and ice (most notably the Bering Sea land bridge) that joined Asia to North America and possibly became the earliest inhabitants of the Americas. How these people fanned out and filtered across the Americas remains a mystery, but some found the corridor between the Pacific Ocean and the coastal mountains and eventually formed

1

what we know today as the various nations of the Northwest Coast. These groups were made up of skilled trackers, hunters and fishermen with the capacity to survive in the harshest environments, and they developed an animist view that everything in the natural world was equal and shared a life force. Shamans explained the origins of all things and the interaction between the natural and spirit worlds, and these narratives were told and retold throughout the long winters. Common to all these Northwest Coast groups were the tales of Raven, a creature that had been present since the beginning of time, had criss-crossed the entire coast and had passed into the spirit world. Raven had an insatiable curiosity that forced him to move constantly in search of new wonders or to meddle incessantly in the affairs of humans and animals.

Science explains that about 4,500 to 5,000 years ago the trade winds shifted, so that they blew from Japan across the Pacific and struck the coastal mountains. The winds swirled into thick clouds that deluged the coastline with rain for months at a time. Temperatures warmed, bringing predictably rainy winters and warm summers, and lush vegetation such as the Western red cedar multiplied with astonishing speed. As the forests were growing, the ice was receding and the seas opening up. A small group known as the Unangan people settled on the Aleutian Islands and the Pribilofs and became proficient seafarers and fishermen. Most of the subsistence hunting groups, however, sought warmer climates and moved steadily down the coast. They found ample food supplies of fish and game and the resources provided by the dense forest, and permanent settlements soon appeared, tucked into the protected bays and along the many salmon-bearing streams. Hundreds of similar villages popped up, isolated from one another to the extent that their inhabitants developed distinct languages, cultural practices and artistic styles. They were, however, seekers and travellers by nature and soon sought to discover their surrounding world. As fishermen, they were constantly advancing their canoe-building technology, allowing for longer ocean voyages with larger crews. People from geographically distant villages soon began to trade, join in ceremonies and meet in war. All this interaction gave them a greater understanding of their collective histories and new insights into the

structure of the natural and spirit worlds, and it allowed groups to share their stories and dances throughout the Northwest Coast.

The winter ceremonial season, the time of the potlatch, or "Giving of Gifts" in Chinook, was the catalyst for a surge in artistic production and excellence. Hosted by an individual chief who extended invitations to many related and distant dignitaries, the potlatch was the place social and political decisions took effect and the place respect was paid to past chiefs and to the significant events that had occurred since the last gathering. Preparation for a potlatch, which sometimes required years of planning, often began with the commissioning of a totem pole to honour a past chief. The reigning chiefs would establish the structure of the event, and then the artists were delegated to produce ceremonial pieces such as masks, headdresses, regalia and props for the theatrical presentations, as well as beautiful and ornate objects to be given as gifts. The number of skilled artists was a testament to the wealth of the host village, and their work—from monuments such as elaborate poles and beautifully woven robes to detailed utilitarian objects such as intricate boxes and exquisitely carved bowls—was present throughout the village and particularly inside the ceremonial halls.

European Contact and the Influence on Northwest Coast Art

When the Russians began exploring the far northern Pacific Ocean in the early eighteenth century, they came into contact with the First Nations living on the Aleutian Islands. They also hunted sea otters and discovered that the pelts could command high prices from the Chinese, with whom they had traded since the late 1600s. Trade quickly expanded into Europe, triggering a growing demand, and the ensuing competition brought many entrepreneurs to the North Coast in search of the valuable furs. The strategic centre of the sea otter trade was the Pribilof Islands, off the coast of Alaska, which drew ships up the entire Pacific Northwest coastline and led their crews to make contact with all the nations of the Northwest Coast.

By the 1850s the sea otter population was all but depleted, and with growing economic pressures at home following the Crimean wars, Russia sold the Alaskan territory to the United States. Adventurers flocked to this inhospitable land: dreamers chasing the gold rush; early lumbermen harvesting the old-growth forests; builders harnessing the rushing rivers

for hydroelectric power; oil barons extracting barrels of crude—a steady extraction of resources (and resulting damage to the birds, animals and fish that depended on these lands) to southern markets by ship and pipeline. For a brief period, artistic production and cultural activity on the Northwest Coast flourished as well. Foreigners traded actively for traditional objects from the "last frontier," and Northwest Coast artists used the arrival of steel tools to increase their traditional range of products to include more contemporary jewelry making (which began with the melting and reforming of coins traded with Russia and the United States). Chiefs understood that more foreigners posed a threat to their territorial control, and they increased the frequency and scale of their potlatches to restate and affirm their positions. More potlatches and more trade meant more opportunities for artists to create and showcase their work. The quality, diversity and sheer number of objects drew the attention of museums internationally, and Eastern American museums saw the opportunity to build collections that would rival their European counterparts.

This sudden upswing in cultural activity came to a dramatic halt in the latter part of the nineteenth century. A proliferation of foreign diseases such as smallpox decimated the populations along the Pacific Northwest during the 1860s and 1880s. At the same time, the Canadian and U.S. governments outlawed the potlatch in 1884, prosecuting individuals who participated and confiscating and relegating many objects to museum collections. Later, the global influenza epidemic after the First World War had a particularly severe impact on First Nations people in North America. A period of cultural darkness descended until the 1960s.

In search of work, education or sometimes to escape the trauma of residential schools, many contemporary Northwest Coast artists left their traditional communities and moved to urban centres in the 1960s. There, the artists met each other, saw museum collections, delved into cultural issues, formed artist groups, studied their own tribal art within a broader context of Northwest Coast art and competitively sought to create work that rivalled the historic masterpieces. In the late 1960s, galleries, shops and museums were city-based, bringing artists and collectors together, and collectors recognized the need to support

career artists who were also being called upon to create works for ceremonial use. During this time ceremonial events grew exponentially in number and scope because artists, excited by the quality of their output and the history of their works, returned to their communities. Collectors loaned pieces and attended ceremonies to see these extraordinary masks and regalia pieces being danced.

At the same time the West Coast was coming of age. Cities were expanding, with the help of Pacific Rim trade, the birth of new industries from Boeing to Microsoft, and the hosting of world events beginning with the Seattle World's Fair in 1962, Expo 86 and, most recently, the Vancouver 2010 Winter Olympics. Modern artists began to receive significant commissions for new pieces, and their work began to be displayed prominently in public and corporate art collections. Major museums were created or expanded to showcase extensive Northwest Coast collections and to include both historic pieces and the work of modern artists. Over only twenty-five years, ceremonies

that featured paper-bag masks and dime-store headdresses evolved to ceremonies and an art market that offer spectacular masks, robes, jewelry, paintings and prints produced by name artists with an international following. The foundation for a secure cultural future seems to have been laid.

Contemporary Northwest Coast Art

The biggest influence on contemporary aboriginal art internationally is cross-cultural pollination, and Northwest Coast art is no exception. Artists have had opportunities to visit other aboriginal nations in their traditional territories and see how language and culture are preserved, how the political process works and conflicts are resolved, and how environmental issues are addressed; these opportunities have in turn helped artists build cross-cultural allegiances, develop collaborative projects, initiate art exhibitions and maintain friendships. Sharing ideas about artistic themes and techniques has also led artists to explore new designs and new media.

In the past decade, aboriginal groups have used such non-traditional media as film and animation festivals, music of all genres,

theatre and dance—from ballet to modern—to explore and, with some effort, to showcase their ideas, not only to Western audiences but also to other First Nations. Arguably, aboriginal art is defined as a continuous representation of a place and history, and these artistic forms might be viewed as a new way to document tribal history. There is no agreement, however, on how to preserve these cultural traditions: some believe individual groups should remain separate (from each other and from non-aboriginals) to preserve their uniqueness, whereas others believe it is important to stay current and modern by embracing all new ideas. Similarly, some believe youth should stay in their communities to stay connected to their Northwest Coast roots, whereas others believe that visiting other nations helps to strengthen commitment to issues shared by all aboriginal groups. Thanks to new technologies, artists can be based in their home communities and still keep up with trends and ideas, galleries and collectors in urban centres around the world.

Regardless of the methods used to preserve and reflect their history, several common themes are emerging in contemporary First Nations art. Deeply rooted in the teaching of all aboriginal nations is respect for and interaction with the environment, and the past decades have seen a massive escalation in the harvest and despoliation of the world's resources: the loss of salmon-bearing streams and bird and animal habitats, rapid depletion of virtually all the first-growth cedar forests, increased pollution and the threat of future calamities such as oil spills and mudslides. So, even the most traditional artists can and must represent modern issues in their work to be relevant, and most contemporary artists have created work that is about specific events or long-running environmental issues.

In addition to more contemporary themes, artists have turned to modern materials such as bronze, polymers and aluminum to solve problems that arise in commissions for public art and outdoor installations. Wood is susceptible to cracking and aging, particularly in climates with distinct winter and summer seasons, whereas cast or fabricated materials not only

offer greater longevity but also ensure that monumental works will not lose value because of degrading materials. Using these new materials, or even just using wood laminates, also allows for a wider range of shapes to be considered. Glass has had a significant impact on aboriginal art for many reasons: it can look and act like many other materials, it can be made to incorporate other materials within it and it has its own unique features, such as translucency. The Pilchuck Glass School, north of Seattle, is considered among the most prominent glass art schools in the world. Pilchuck (along with other schools such as Emily Carr University of Art + Design and the Freda Diesing School of Northwest Coast Art) now has an annual artist-in-residence program for an aboriginal artist, and many aboriginal artists have considered glass as a possible new medium, as teaching programs, exhibitions and collaborative projects have begun to emerge in traditional villages around the world.

Despite changes to the materials being used, universal to all Northwest Coast art and to both its historical and contemporary art forms is the use of formline design. These basic shapes—known as ovoids, U (and split-U) forms, T forms and S forms—are often described as skeletal and muscular in their relationship to each other, because they establish the overall structure of the work. Sometimes formline can be literal, describing crest animals or visually narrating an event, or it can be highly abstracted, representing private information held by the family, dancer or secret society, in public forums such as ceremonies. It is frequently combined with elaborate painting and/or complex sculptural forms that require the artist to excel in both two- and three-dimensional art forms. At its highest level, formline can be the most challenging, unforgiving and least understood of all the Northwest Coast art forms, and despite its universal application—from huge house fronts and canoe prows to the detailed surfaces of smaller bentwood boxes and the elaborate geometry of sculpted masks—mastery of this complex art form is rare.

The collection of works that follows showcases some of the finest work being produced by Northwest Coast artists today. The pieces represent a wide range of concepts that are either culturally important or of personal significance to the artist who made them, and they highlight two themes that remain prominent: (1) the constant evolution of the coast as demonstrated through ideas of environmental protection and (2) the inter-actions between coastal communities, and sometimes between communities on a global scale, as shown by cross-cultural subjects. Some of the pieces reflect a dedication to tradition, whereas others express a modern vision using tradition only as a basis for further self-exploration. Although some aboriginal nations view cultural protection as building a high fence and working from within, on the Northwest Coast people are always on the move, always searching and, like Raven, always excited by new discoveries.

All the stories accompanying these works are told by the artists, so that their cultural or family version, passion and purpose are recorded. The contemporary art form continues to expand, as new artists, schools and museums and galleries build collections and hold exhibitions—group, solo and themed exhibitions—showcasing the extraordinary evolution of one of the world's great arts. No period in history has seen such dramatic change, and never has the challenge been so great to preserve history and tradition as well as address the unfolding changes to the culture and the pressures of the surrounding world. Although there is room to capture only a small selection of artists currently contributing to this dynamic process, this collection reveals the ongoing innovation and conviction of new and estab-lished First Nations artists.

Traditional

Shark Mask, 2000

ROBERT DAVIDSON

Haida

Red cedar, cedar bark, acrylic paint
26 × 20 × 9 inches

K'AAD AWW (MOTHER of Dogfish) has a song and dance that was related to me by my auntie Helen Sanderson.

A person rises early and goes down to the water's edge at low tide to relieve himself. He hears a sound farther along the beach and goes to investigate. There he finds a shark, making the sounds of impending death, stranded in the shallows by the receding tide. The person memorizes the sound, and it becomes the song. He pushes the shark out to sea, and it swims away. He then takes the shark as his crest.

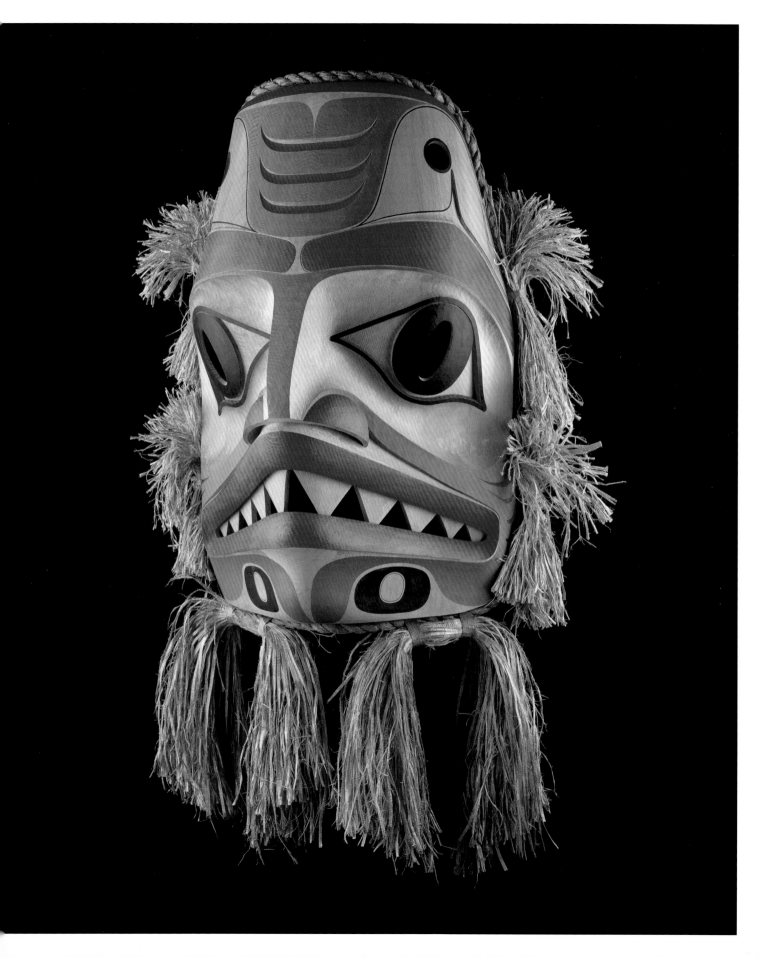

Eagle Clan Helmet, 2006

KEN MOWATT

Gitxsan
Red cedar, horsehair, acrylic paint
13 × 15½ inches (diameter)

THE CLAN HAT is a most prestigious object in any of the Northwest Coast villages. It is a symbol of royalty on any occasion. As with all the important objects of the tribes, its introduction to the feast hall is usually as lavish as that of a living person. The clan hat is given a name and its family history, and songs and dances are witnessed in the feast hall. The object is given the breath of our ancestors.

This Eagle Clan hat tells the story of Eagle, the majestic flying creature that guides the spirits of our departed to the spirit world. He will soar high above the sun to another land.

It is interesting to note that some cultures believe Eagle delivers karma to the living trees, and if you are placed high on the tree, you rank highly in your achievements.

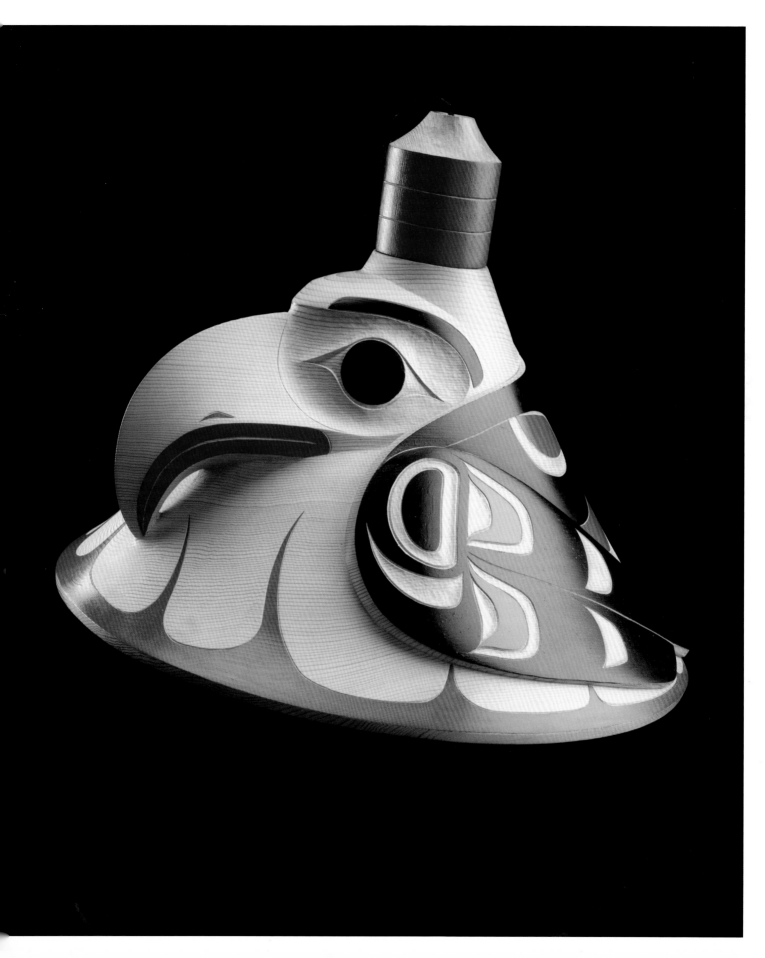

Frog and Human
Portrait Mask, 2003

DEMPSEY BOB

Tahltan-Tlingit
Alder, acrylic paint
13½ × 9 × 5 inches

MANY STORIES DESCRIBE the origins of crests, history or
teachings. Often they tell of animals travelling between two
worlds, gathering and sharing knowledge.

We have many stories related to the frog and its unique
attributes that allow it to move from the forest to the water and
to interact with humans. We wear our crests on the forehead, so
this mask of a human form wearing a frog headdress represents
the Frog Clan. In turn, the frog in the headdress is wearing a
headdress of a human.

On the chin of the mask is Frog, who sits in front of the
speaker's mouth telling of the ancient wisdom of the frog. Frog
is always a protector of the natural world.

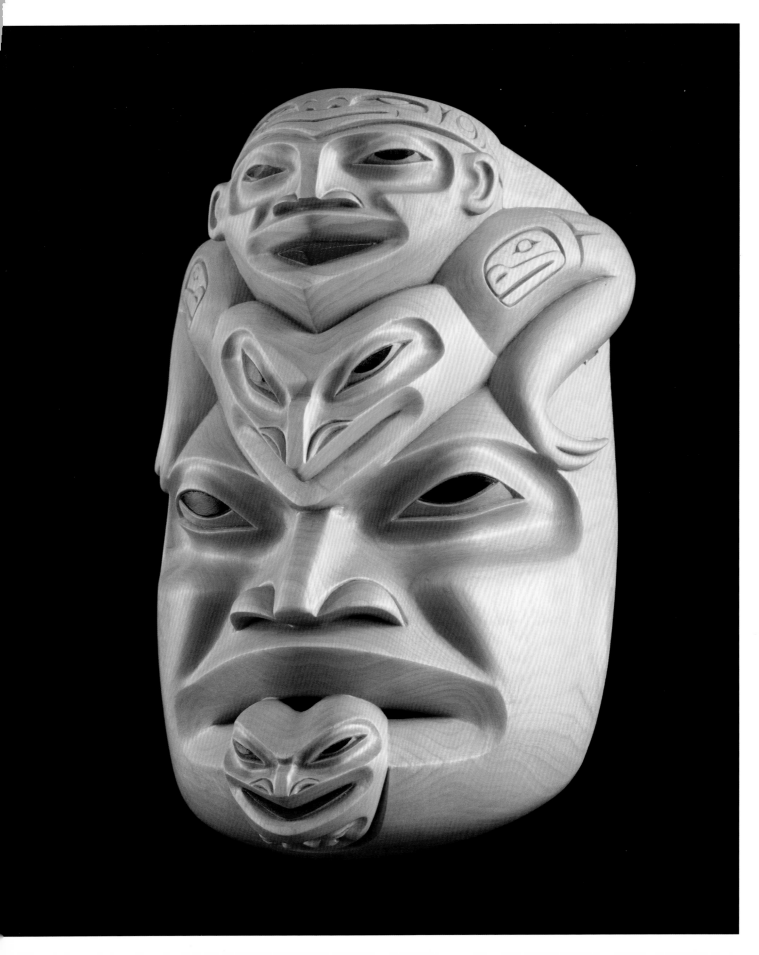

The Man Who Married
a Female Bear, 2008

NORMAN JACKSON

Tongass/Tlingit
Alder, paint
11 × 8 × 5 inches

KAATS WAS THE eldest of four brothers who lived on Rudyerd Bay a long time ago. He would hike far up in the mountains with his dogs to hunt grizzly bears. The dogs, bounding ahead, found a den, and their barking brought the old male grizzly out. He grabbed the boy and threw him into the den and then turned his attention to the dogs. Rolling into the den, the boy reached out and touched the young female bear, who immediately transformed into a woman. She furiously dug a hole and hid him by sitting on the hole.

The old bear chased away the dogs and then came into the den, searching for the boy. His wife told him that there was no boy and that only a mitten was thrown into the den. The bear searched and, finding nothing, stormed out to search outside.

When the dogs returned home without Kaats, his younger brothers made plans to search for him. First, the two middle brothers prepared for the journey by leaving their wives and purifying themselves by drinking and bathing in seawater. The youngest refused to leave his wife, and his elder brothers were highly critical of his decision. The second-eldest, after many days of fasting and purification, declared himself ready and set out with Kaats's dogs.

Kaats's new bear wife saw arrows flying into the den on a beam of sunlight, which she identified as the thoughts of Kaats's brother, but she knew he would never find her and Kaats because he had prepared himself improperly. She pulled the arrows from the wall and tossed them outside. The brother searched the hills and valleys but found no trace of Kaats.

The third-eldest brother continued his ritual of preparation for several more days before he left with Kaats's dogs for the search. Again, the arrows of thoughts flew into the den, and again the female bear tossed them out. "He is only pretending to purify, and he will never find you," she told Kaats. The brother returned home without finding any sign of Kaats.

The youngest brother continued to stay with his wife and drink seawater. He announced that he was ready to begin the

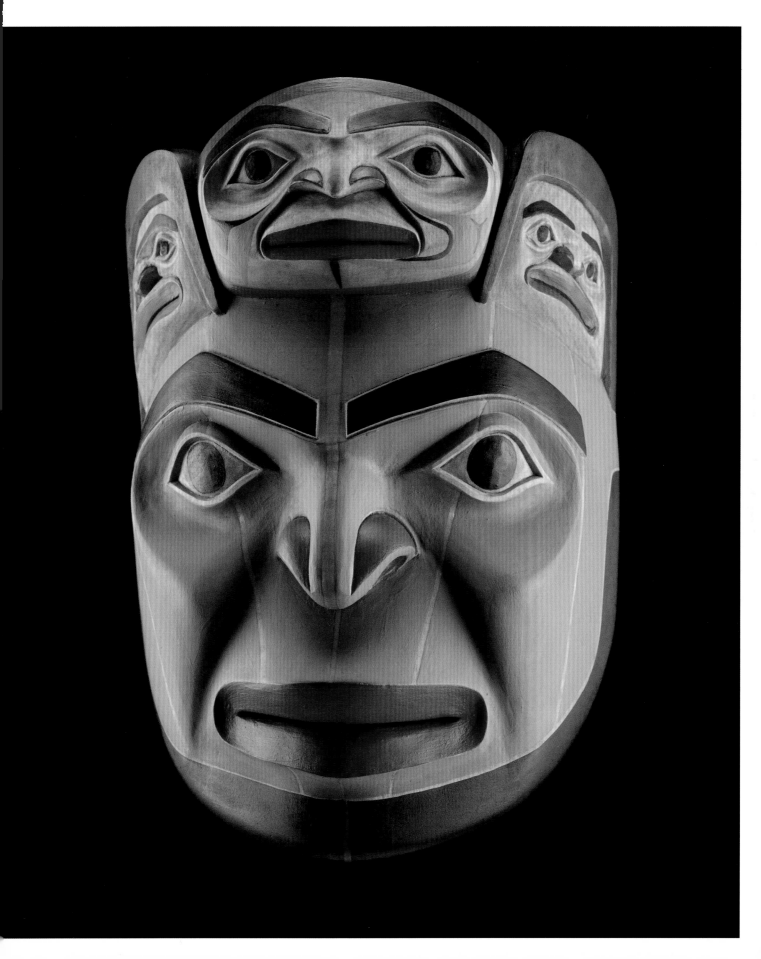

search, but his brothers tried to dissuade him because he had not honoured the rules of ritual, and disaster awaited him in the mountains. He paid no attention, for he knew that his wife had cooperated with his preparation and his power was strong.

The arrows again flew into the den on shafts of sunlight, and the female bear knew that this brother had sacrificed himself and was fully prepared because the arrows were embedded in the walls and could not be removed. When they heard the dogs barking in the distance, the bear wife told Kaats to meet his brother and tell him all that had happened. The dogs recognized Kaats and stopped barking. Then Kaats told his brother to return home and tell his family that he would visit in the spring when the bears come out of their den.

In the spring the family watched for Kaats's return, and finally he appeared with his bear wife and cub children. His bear wife instructed him not to look at his human wife or to speak with her. Kaats stayed in the village and with other tribesmen hunted seals that he took to his bear wife and cubs. When he caught two or three seals, the meat was shared, but if he caught only one the cubs ate it all, forgetting their mother. Kaats was unhappy with this disrespect for his wife, and he thought up a scheme to use a weir of rocks to capture many fish at a time in a slough.

One day while Kaats was returning from seal hunting, his human wife hid behind a house and stepped out into his path, forcing him to look at her. His bear wife knew immediately what had happened. When he returned home she approached him and shoved him for doing something that was forbidden. It was not a hard shove—and the female bear knew that what had happened could not have been prevented—but the bear cubs, seeing their mother's aggression, sprang at Kaats and tore him to pieces. The bear mother left the village for the mountains, singing a song of sorrow whose words were "I wonder where my husband has gone—I wonder where my husband has gone—he left me—he left me."

Kaats's sealing partner heard the song and told the people what had happened. The song has been sung by the descendants of Kaats, and their longhouse has always been known as Kaats's house.

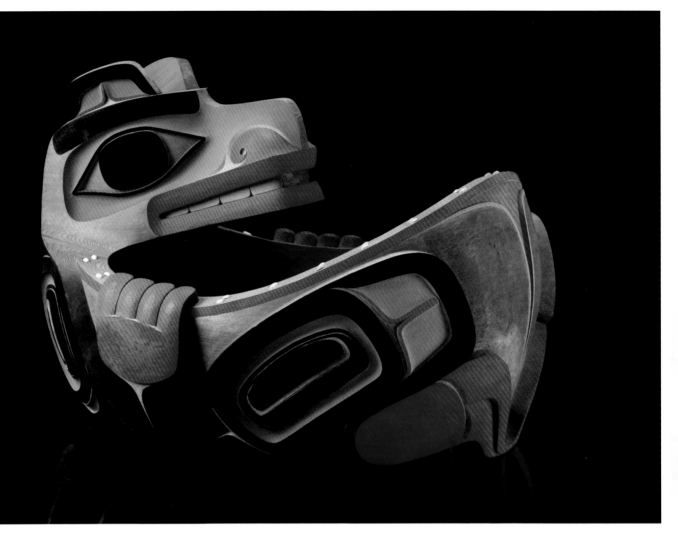

Bear Feast Bowl, 2008

WILLIAM KUHNLEY JR.

Nuu-chah-nulth/Ditidaht

Red cedar, acrylic paint
24 × 34 × 25 inches

LARGE FEAST DISHES were carved to feed the people assembled
for potlatches. I wanted this particular bowl to have the classic
form of a Northwest Coast canoe, with pleasing shapes for the
stern and bow. I had chosen to represent Bear, but it turned out to
be quite a challenge to obtain a streamlined form that looked as
though it would be sitting in the water.

Revered Enemy, 1996

JOE DAVID

Tla-O-Qui-Aht/Nuu-chah-nulth
Alder, horsehair, acrylic paint
10 × 7 × 5 inches

THERE ARE QUITE a few of these decapitated head carvings in collections going back to first contact, and I am most fascinated with these because of their perfection in expressing death—not in a macabre sense but in achieving a full expression of lifelessness in a person who was once full of life. It's not easy to carve a mask that reflects the life of a specific being and person, and it turns out it's doubly difficult to achieve its opposite, death, and—sometimes more specifically—anguish and death.

Because of my background in art and portraiture and my passion for people-watching, I have long understood the need to accurately reflect and express not just what I see but also the actions and emotions that underlie it. My ancestors mastered portraiture in a complete range of characters in their known and created natural and supernatural worlds. And for me or any of my contemporaries to strive for anything less would be a weak link in an otherwise powerful and profound chain of human artistic achievements. I believe some of these carvings depicting decapitated heads were made to represent people of value, such as nobles or a revered and great warrior enemy. The actual heads were most likely displayed with honour and respect, just as the carvings are.

Revered Enemy was inspired by war stories of heads taken in war and brought back to the victor's village, where they were displayed in ceremony before being stuck on a stick for all to view and witness. Some of the skulls were then kept in a box, and others were taken to remote places in the forest or in caves.

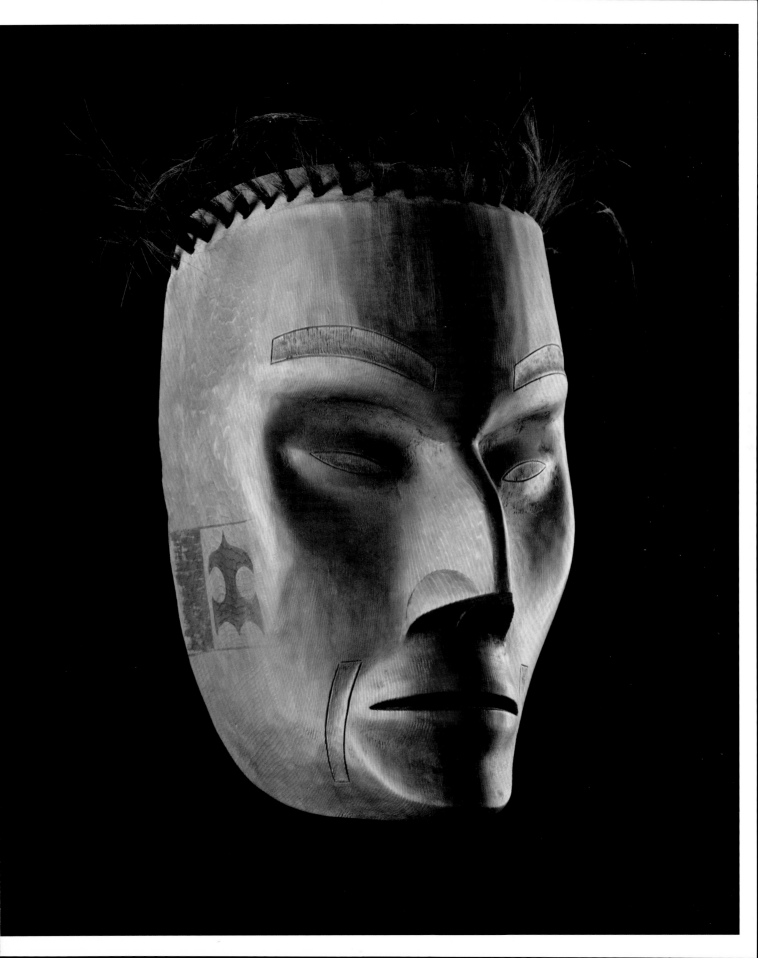

Beaver Frontlet, 2009

EUGENE ALFRED

Northern Tutchone/Tlingit

Alder, abalone shell, acrylic paint

7¼ × 5 × 2 inches

BEAVER WAS USED as a crest of the coastal Tlingit only, not of
the interior Tlingit or the Dene, Tutchone and Kaska tribes of
the central Yukon. My family originated on the coast, and four
brothers, one of whom was my grandfather, moved into different
parts of the interior Yukon, including quite far north, and married
and settled there. We did not have the strict rules for carving
that are found on the coast, and styles were representative of the
mixed influences of the surrounding nations.

There is a character known as Beaver Man that is universal to
the Yukon tribes: he had a human body but the tail, face and teeth
of the beaver. He was a traveller and brought skills with wood
that became commonly used by the people.

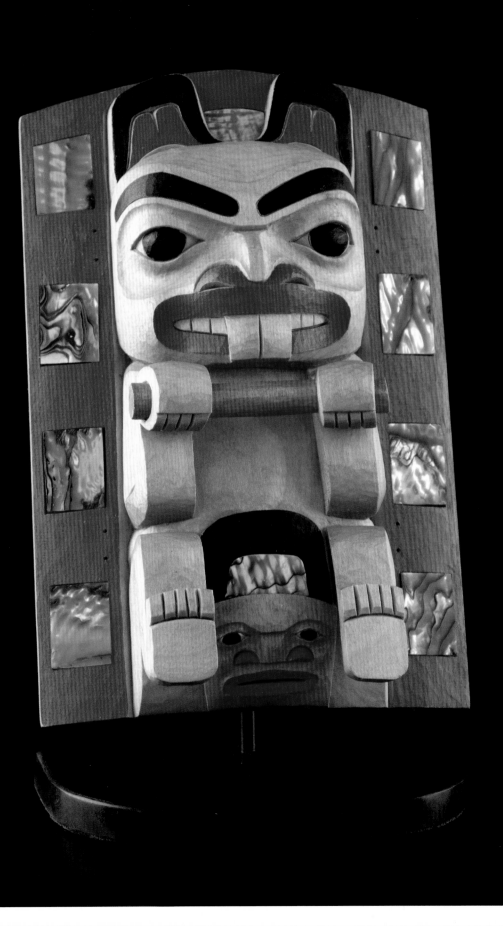

Porcupine Headdress, 1999

WAYNE ALFRED

Kwakwaka'wakw
Red cedar, cedar bark, paint
26 × 17 × 16 inches

THE PORCUPINE IS part of the Animal Kingdom ritual from Gilford Island.

There was once a woman of noble birth who sought spiritual guidance in the forest after an argument with her family. As she strolled the beach she noticed she was being followed by Bakwas (Wild Man of the Woods), who was sneaking up on her to lure her into the ghost world. She confronted him, and he offered her a special gift of directions to a cave where the animals host their ceremonies. She accepted this gift and followed the trail into the forest to where the cave was meant to be. There she met a mouse and, using goat tallow as a lure, convinced the mouse to show her the entrance to the cave.

Inside the cave she surprised the animals dancing in their human forms. Their many different animal skins were hanging around the perimeter of the hall. The Chief of the Animals, Porcupine, offered her as a gift the song and dance that were being performed. She learned this ritual and took it back to the village, where it is still danced today.

The animals that were present at the ritual included Wolf, Kingfisher, Porcupine, Mouse, Bakwas, Deer, Owl, Raccoon, Sea Otter, Land Otter, Mink, Weasel, Martin, Black Bear, Grizzly Bear and Red Snapper.

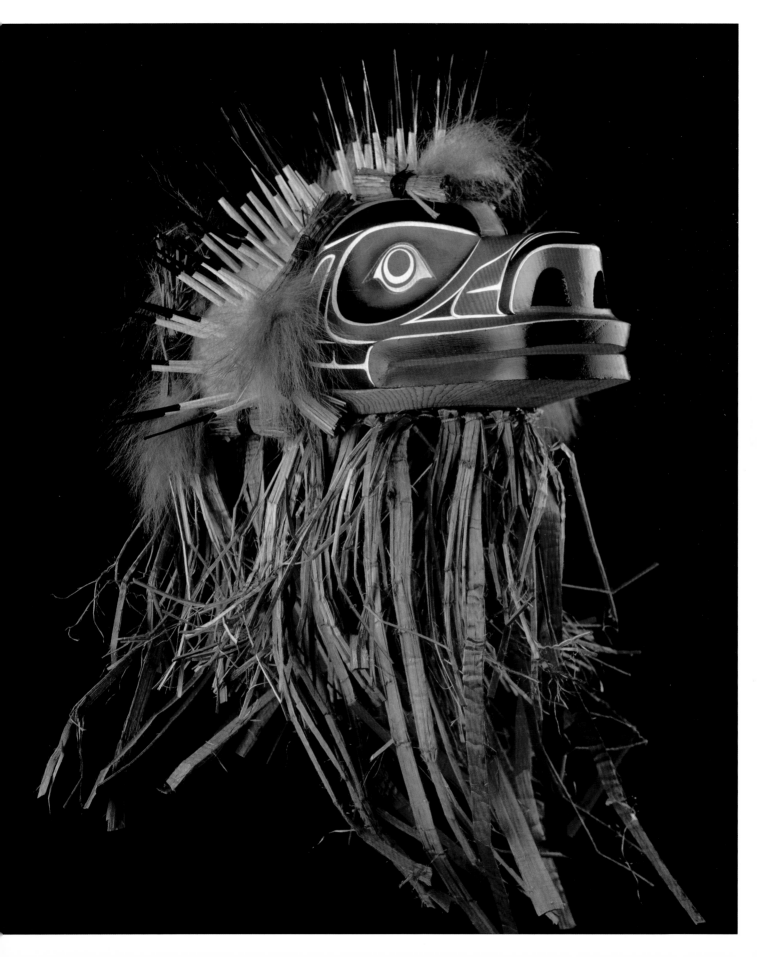

Northern Warrior, 2006

STAN BEVAN

Tahltan-Tlingit/Tsimshian
Alder, operculum shell, horsehair, acrylic paint
10 × 10 × 7 inches

WE HAVE MANY Warrior stories in our history and family, and
I have been interested in the art of the warrior since I began
to carve. Who we are is what we are wearing, and chiefs and
warriors would draw on the rich history of their land and people
to create masks, regalia and full armour.

As in many nations around the world, in our history two fully
armoured warriors would duel to decide the outcome of a battle.
This piece depicts a war helmet with the visor. It is a mask made
into one piece, to sit on its own as a helmet and visor would.

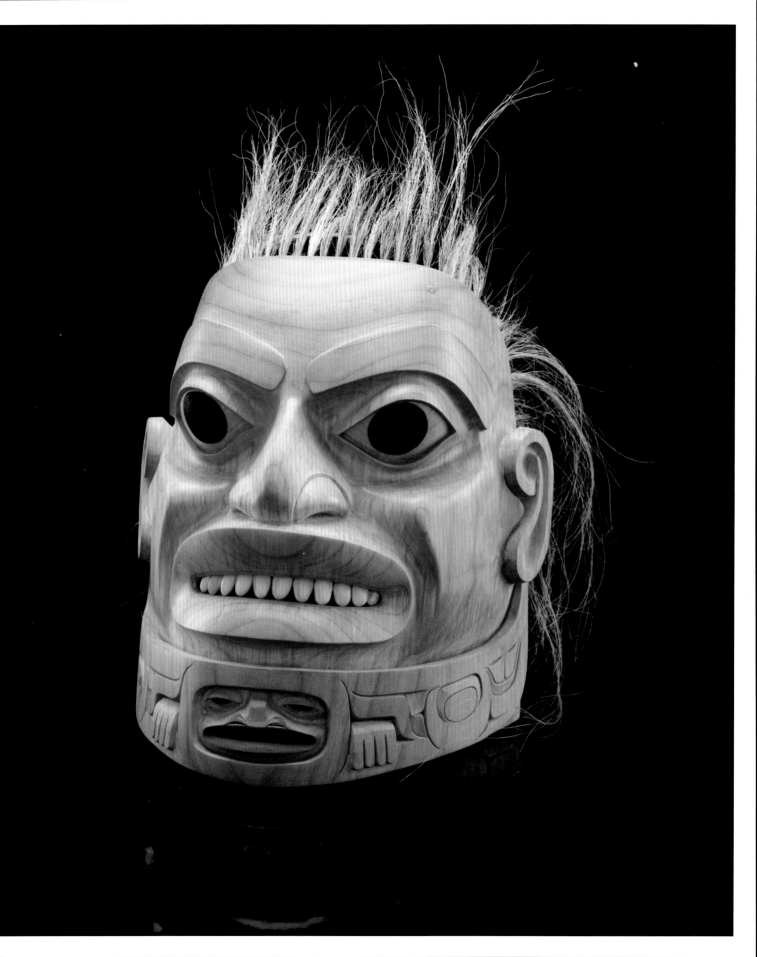

Raven Salmon Sun Mask, 2006

TOM HUNT

Kwakwaka'wakw
Red cedar, acrylic paint
70 × 71 × 23 inches

A story told by Mervyn Child
about Raven, Bear and Salmon

———————————

ONE DAY RAVEN was perched high up in a tree in the sun world. Raven took flight magnificently toward the river where Bear was rubbing a rock. Closer and closer Raven got, but he could not figure out what Bear was doing with this rock.

Raven landed and said, "Brother Bear, what are you looking for with that rock?"

Bear said, "Raven, you can't smell it?"

So, Raven and Bear pushed the rock over, to find a tunnel or tube. Bear jumped in but was too big, so Raven shimmied through the opening to find the supernatural world connected by a river.

Raven had to flap his large wings so as not to drown in the river, which attracted the pale people. They saw Raven and yelled at each other to attack, because Raven is a trickster. But Raven assured them that he had accidentally come by to visit them. So the pale people made a feast for Raven and showed him how to barbecue the salmon for feasting. Raven scraped the scales off the fish to take back with him to the sun world.

When the pale people were sleeping, Raven swam up the river to the tunnel or tube back to the sun world. Bear was still waiting and asked what had happened.

Raven said, "Can't you smell it?" Then Raven released the scales, which turned into salmon in the sun world so that Bear could feast on all this fish.

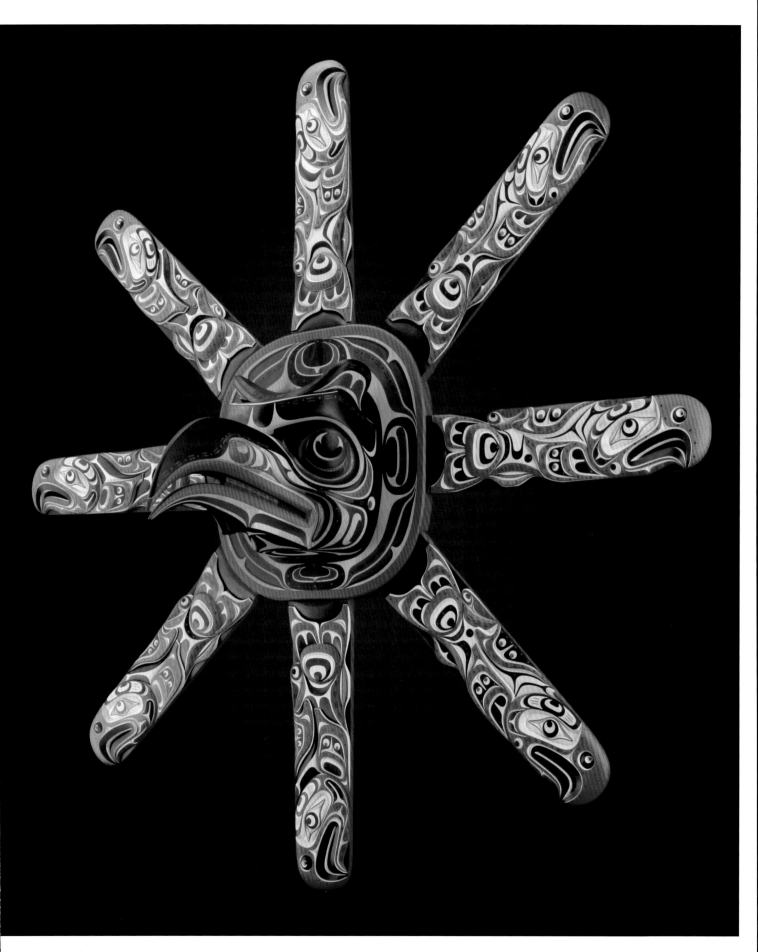

Raven Spirit Mask, 2008

KEN MCNEIL

Tlingit/Nisga'a
Alder, horsehair, acrylic paint
13 × 10 × 6 inches

THE RAVEN SPIRIT is the transformation between human and Raven, with the skills, knowledge and attributes of Raven being transferred through a family lineage to help the people. Raven possesses this knowledge from his presence at the beginning of time and as a witness to the changes to the world. His curiosity has taken him on a journey across the world and, although he is a meddler in affairs other than his own, he knows the sources of all things and how they came to be. Much of his meddling has transformed the world, as Raven has shared with different groups, spreading gifts and knowledge along the coast.

Frog is the Spirit Helper speaking to the people who seek his knowledge. Frog has a unique wisdom from his ability to move between many worlds, such as the forest, the water and the world known to people. This has given him a valuable understanding of the connections and secrets of the universe.

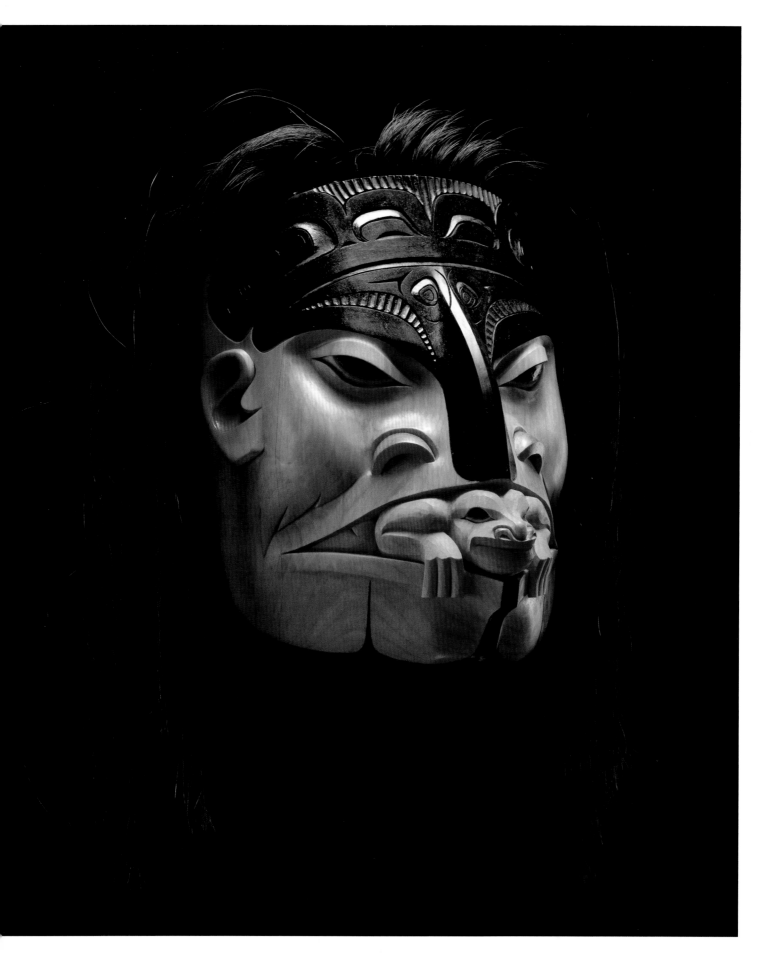

Eagle, Raven, Hok Hok,
Killerwhale totem pole, 2004

RICHARD HUNT

Kwakwaka'wakw

Red cedar, acrylic paint

65 × 13 × 21 inches

THE TOP FIGURE of the model pole is an eagle, whose wings are joined to the body by mortise and tenon. Eagle is the main crest of the Kwagiulth people of Fort Rupert. The second figure is the raven. Raven is the main crest of the Hunt family from Fort Rupert. The third figure represents a Hok Hok, which is used in the cannibal dance. Hok Hok is said to crack open a human skull and eat the brains. The fourth figure is a killer whale. To me, Killerwhale represents the spirits of our elders: the dorsal fin has a bear's head on it, the blowhole represents an eagle and the whale has a seal in its mouth. The Raven is from my mom's house in Kingcome, thus the two-headed serpent.

I always thought this design would make a great full-size pole, but the Hok Hok's beak, the Raven's beak and the Killerwhale's dorsal fin would be too long and might make it impossible because the figures themselves would have to be about six feet long. I've always liked the profile of the pole itself.

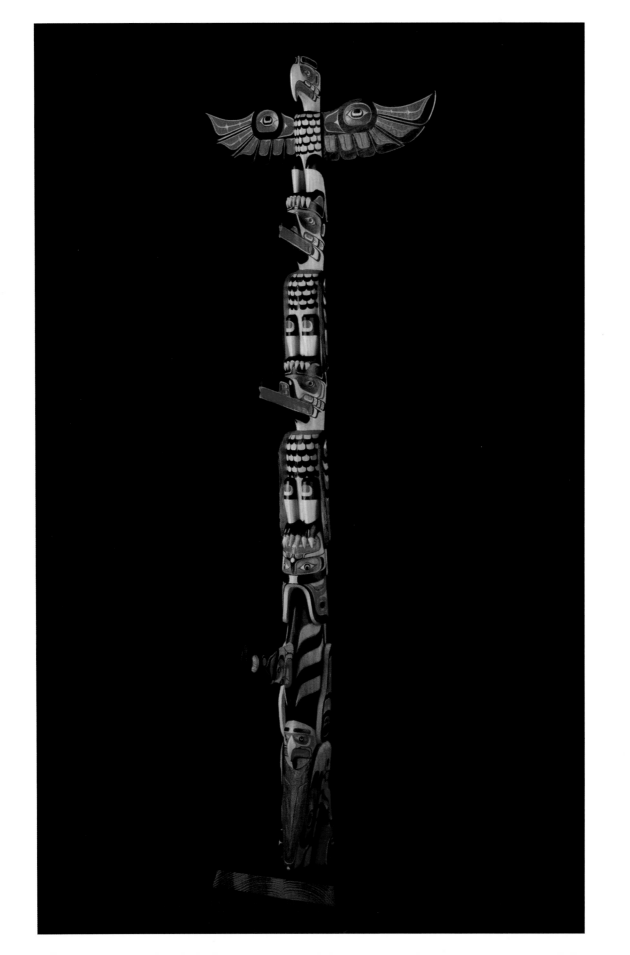

Wolf Headdress, 2001

GLENN TALLIO

Nuxalk
Red cedar, cedar bark, paint
13 × 10 × 28 inches (plus cedar-bark train)

WOLF IS ONE of the first descendants of the Nuxalk people.
He was sent, with a number of animals, to inhabit earth at the
beginning of time by Atquentam, the chief deity residing in
the land above.

Wolf is part of the Sisaok ceremonies, one of two of the most
important ceremonial societies and supernatural masks that
often change into other beings. Among our tribespeople, we also
respect the wolf for its role in balancing nature by keeping game
animals in check.

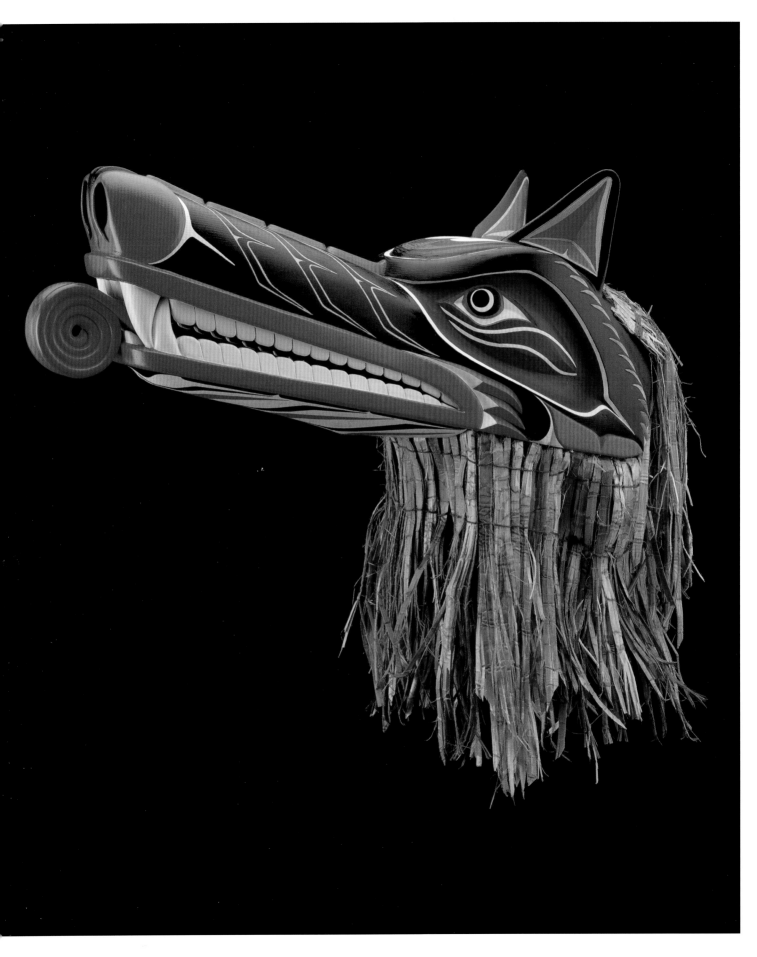

Soapberry Spoon Bag, 2009

TERI ROFKAR

Tlingit

Spruce root, grass, maidenhair fern

15 × 3½ inches

THERE IS NO word for "art" in the Tlingit language. Art was part of everyday life; in fact, the aesthetic of a piece is intertwined with function, allowing us insight into daily life from the past. As children we would eat soapberries up at my grandmother's house. The berries themselves are bitter little things, not much to eat just fresh off the bush. It was back in the kitchen with a French whisk or hand mixer where the real fun began. Grandmother would put a couple of tablespoons of the berries in a large stainless steel bowl and all of us grandchildren would get to take turns with the mixer, slowly adding cold water and sugar. The berries just kept growing and growing, the sweet pink foam threatening to spill out over the edges of the huge bowl. There was always lots for sharing.

Imagine my delight to see a soapberry spoon bag for the first time in a museum. It happened in 1991, when I was demonstrating my weaving for the National Museum of the American Indian in New York City. There was a beautifully woven spruce-root bag with many long, slender carved spoons inside. I had never seen a woven bag like this; after all, my grandmother used a mixer when we ate soapberries. I read the label; it described the spruce-root spoon bag full of carved spoons. Then I read farther... "For religious purposes these spoons were kept separate from all of the other spoons." Really? I had no idea! As I sat on the floor by myself in the dark museum, enjoying everything about the bag, it hit me, and I laughed right out loud. The label was trying to explain something the collectors did not understand.

Lack of knowledge in this case created complex religious protocols out of Native scientific knowledge. My experience is that Native science—just pure science based on literally thousands of years of observation, trial and error—is embedded in the art, just as are our faith beliefs. Here is the science behind the bag: soapberries create firm, sweet berry-flavoured foam. If, however, you introduce oil, the foam won't form. So to keep this from happening, the spoons used for our precious soapberries were kept separate from those used for seal, fish, deer or other fatty foods that might contain oils.

This soapberry spoon bag was inspired by the old one, now in storage near Washington, D.C., in the collection of the National Museum of the American Indian. I still eat soapberries, and my granddaughter and I will be whipping them up in the fall. The joy continues...

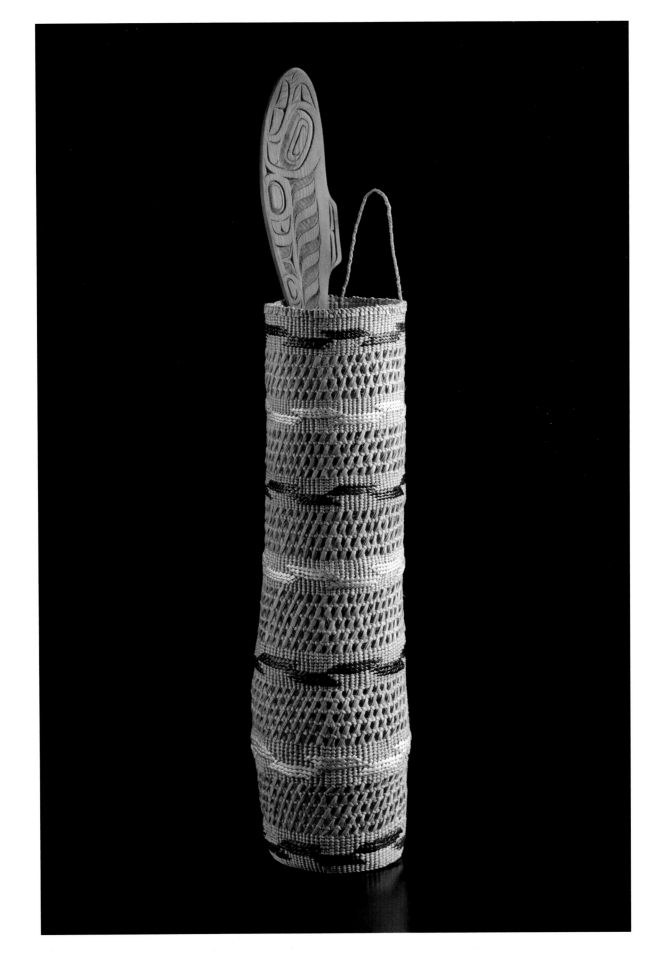

Mouse Woman Mask, 2006

JAY SIMEON

Haida/Cree
Red cedar, sealskin, cedar bark, paint
14 × 19 × 10½ inches

MOUSE WOMAN IS one of the most intriguing characters in Haida narratives. Her role is largely to mediate between the natural and supernatural worlds, and the balance between these two forces is critical to keeping the world in check.

Times of crisis were caused by creatures from the supernatural world wreaking havoc on the natural world, or they might simply have seen something irresistible and then attempted to take it from its owner by crossing into the dimension of time or another realm, like the sky or sea kingdom, where people couldn't enter. At these times, Mouse Woman would appear and offer a strategy.

Often Mouse Woman's advice had to be taken on faith, but if it was followed exactly, a course into these unfamiliar worlds could be charted. Doing so allowed the seeker to gain great personal strength, overcome obstacles and, in the end, recover whatever—or, in many cases, whoever—had been lost.

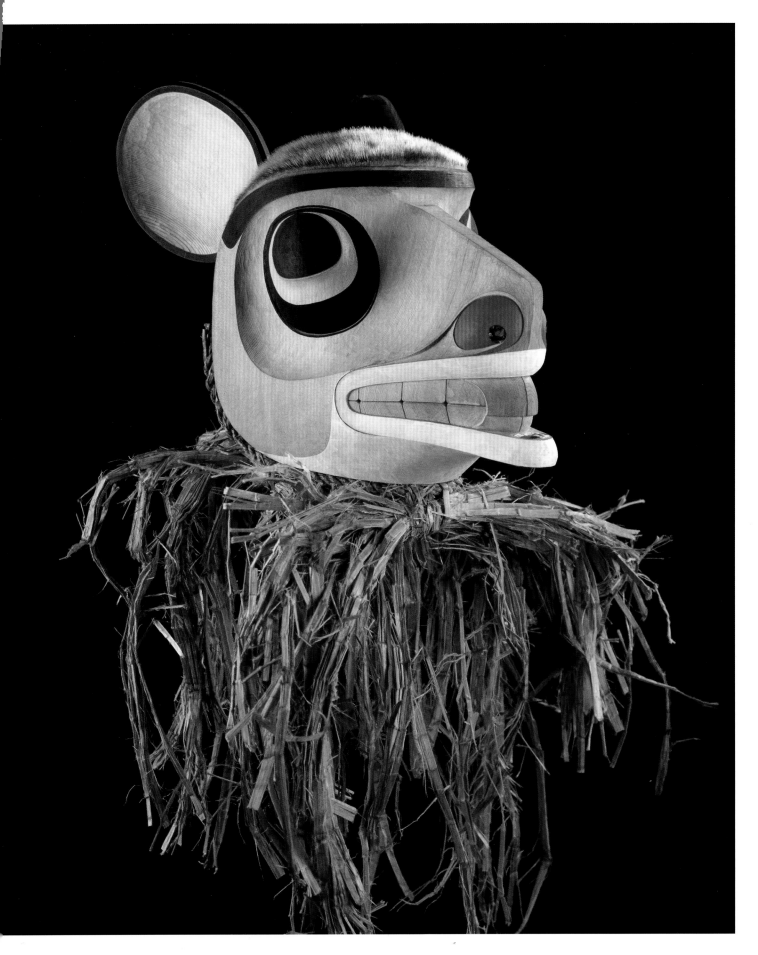

Red Snapper Headdress, 2003

RICHARD HUNT

Kwakwaka'wakw
Red cedar, acrylic paint
13 × 34 × 13 inches

RED SNAPPER IS used in the dance of the animal kingdom from under the sea. The undersea kingdom is a long series of masks, each one depicting a sea creature that transforms into a human. The spine and tail of this headdress move as one, and the lower jaw moves also.

This dance takes a while to complete because there are so many creatures of the sea to perform, such as the whale, the salmon, the octopus and many others, including the sea bear. When dancing with this mask as a human, you stand up. When the song changes, you become a red snapper and dance crawling on the floor.

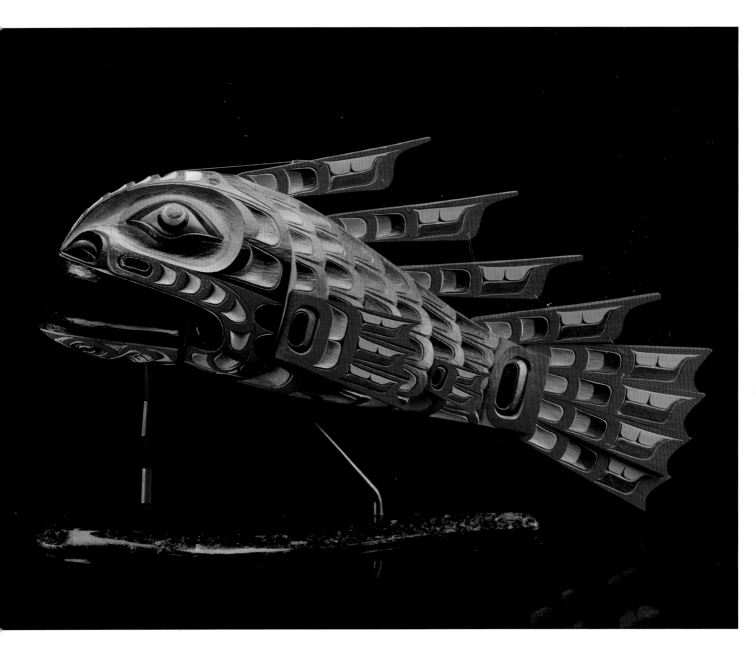

Crooked Beak Headdress, 2003

HENRY SPECK

Kwakwaka'wakw

Red cedar, cedar bark, paint

24 × 37 × 13 inches

THESE THREE HEADDRESSES represent the guardians and attendants to Baxwbakwala- nuxwsiwe, the Cannibal at the North End of the World, and are danced by initiates earning a position with the secret societies. The masks are presented during the Hamatsa ritual, which is our most important dance complex. The initiates spend many years building their knowledge and skills as well as earning the rights and privileges held by secret societies.

In early times, before masks, there were only cedar-bark rings to identify people undergoing the beginning of a spiritual transformation that would be completed by spending months in the deep forest. After a period of fasting and solitude, the spiritual forces of the forest would possess the person and control his actions. The person would return to his village while the ceremony was in progress and enter while still in a possessed state. Over time, he would be tamed and returned to his previous state, though with the knowledge learned in the forest becoming part of his permanent makeup.

Masks eventually came into use, and each of the creatures had a visual and theatrical presence. The masks were often large, both as a challenge to the dancer to perform them in accordance with the strict rules of the society and to validate the initiate's worthiness in a public setting.

The story tells of the disappearance of numerous villagers and the search for their whereabouts. The loss of the chief's daughter Togwid, while berry picking, intensified the search, and the best warriors were sent out in a wide arc to search the forest. Some of these warriors saw smoke from the fires of a village high in the mountains, which was suspicious because the people were beach dwellers, depen- dent on fish and sea life. They approached the village with caution and saw that the village was guarded by three great birds, Hok Hok, Raven and Crooked Beak of Heaven. From one of the houses emerged the cannibal with a villager, whom he proceeded to tear apart, dismember and then put back together, returning life to his body. The warriors under- stood that their villagers were dead. However, by memorizing the ceremony to return them to life, the warriors realized they could still rescue the villagers with the hope of re-enacting the ceremony later.

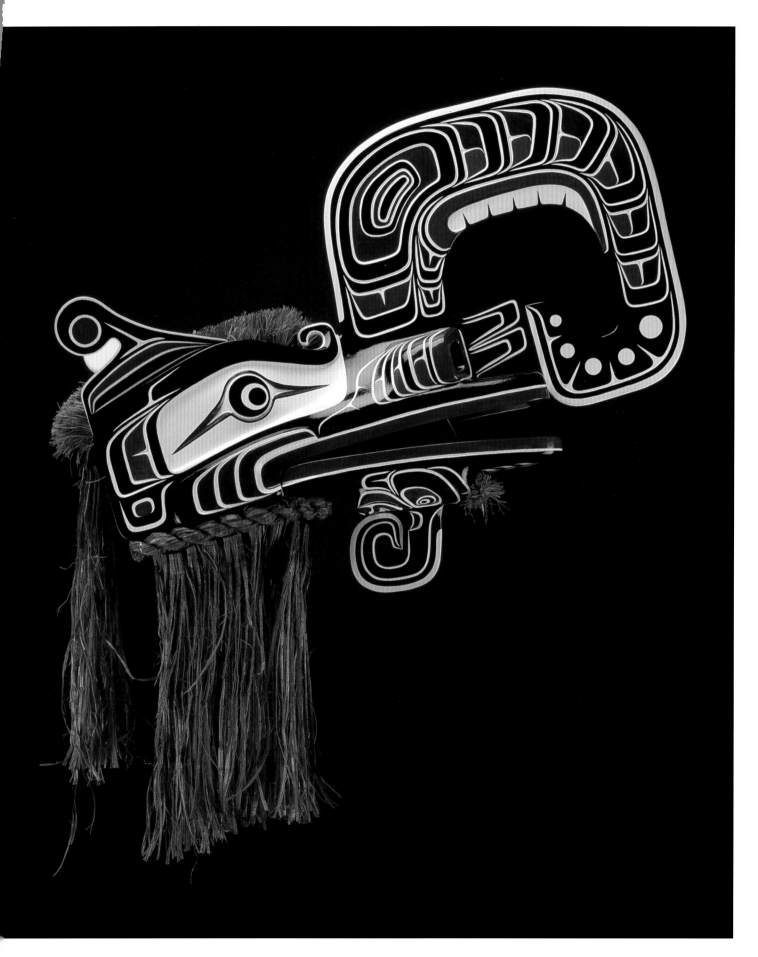

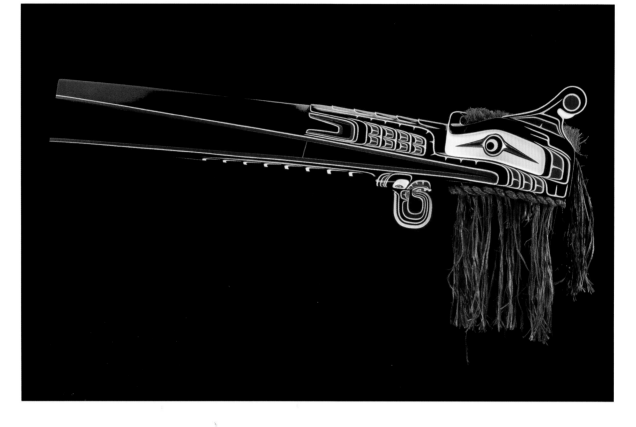

Raven Headdress, 2004

HENRY SPECK

Kwak̲wa̲ka'wakw
Red cedar, cedar bark, paint
13 × 53 × 13 inches

The warriors succeeded in a dramatic rescue whereby they called upon many tricks and diversions to leave the mountain while being pursued by the cannibal and the great birds. The cannibal monster was captured and killed in a pit covered with branches and lined with a bed of hot coals. Upon striking the coals, his burning body transformed into mosquitoes, which continue to feast on the blood of humans today. This story forms the basis of the Hamatsa ceremony.

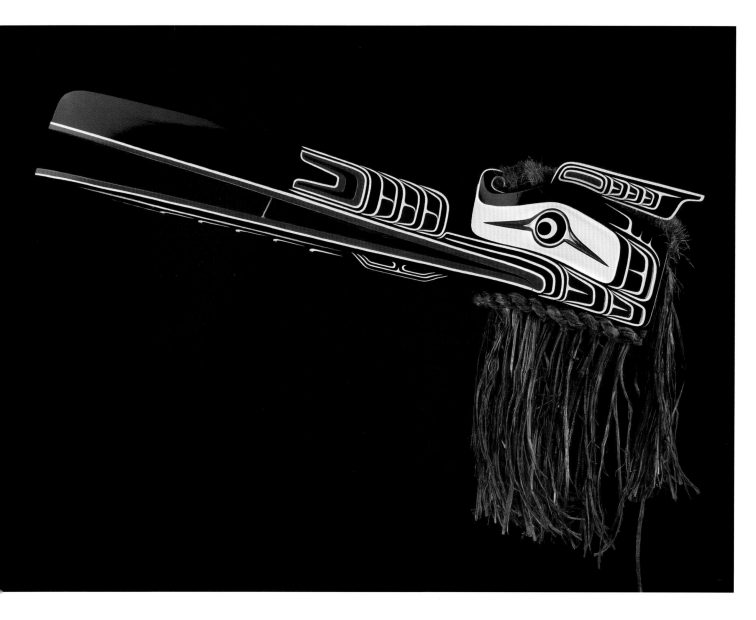

Killerwhale Clan
Chief's Helmet, 1999

NORMAN TAIT AND
LUCINDA TURNER

Nisga'a
Alder, horsehair, paint
19¼ × 18 × 16 inches

THIS HELMET WOULD belong to a high-ranking chief of the Killerwhale Clan, and carving such pieces was delegated to the most important artists of the village.

At major feasts and other ceremonies, the head of each family would wear a headdress to indicate which family crest they represented. The chiefs owned families of slaves whose long hair was cut and used to decorate such pieces of high status. The small crawling figure is the human spirit of the chief.

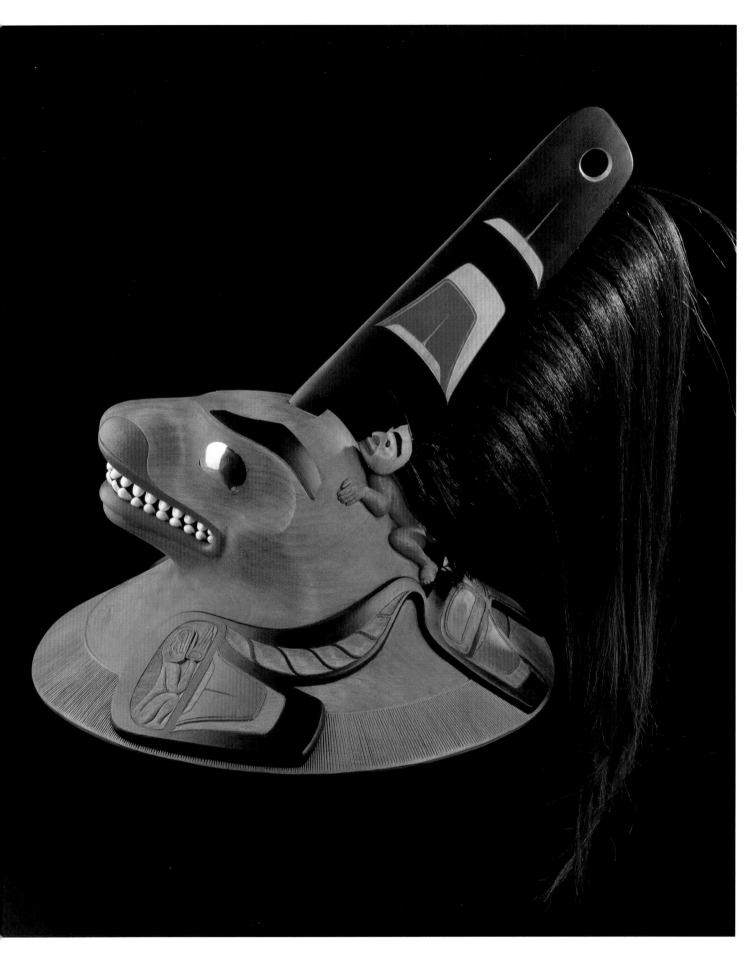

Wildman Mask, 2003

JOE DAVID

Tla-O-Qui-Aht/Nuu-chah-nulth
Alder, horsehair, acrylic paint
13 × 8 × 7 inches

OVER THE YEARS, I've developed my own interpretation of this character, now commonly known as Wildman of the Woods. Parts of my personal view reflect traditional knowledge and ancestral experience, and parts reflect my own inner workings and experiences.

Ever since childhood I've been fascinated with this person known as Ulthma'koke, I suppose because it was a mask that my father liked to carve, and several uncles and other elders too. I don't know where their fascination stemmed from, as they never really spoke of him. Which leads me to think that perhaps he was a character not to be mentioned? As far as I know, his only appearance in ceremony was at the end of wolf rituals known as Tluqwanna, where he was very unruly and even destructive, ripping through the order and rules set down by the wolves. And this was the hook that got me. At first I didn't identify with him, of course, but after many years and experiences and much thinking (followed by much not-/un-thinking and feeling and allowing for sheer

wonder), I have realized that I just might have come to know him and/or have created a "him." Traditionally, there were many of him, each a separate individual, each coming from and once belonging to a specific family and community during a specific period in history—and, I am willing to bet, going back in history much farther than most of the other characters and masks on the Northwest Coast.

Two of my all-time favourite masks of him are in the Royal British Columbia Museum in Victoria, B.C., and they appear to be very old in style and manufacture. Over the years, I have tried more times to do him justice in mask form than any other carving. And I feel that I have come close only a few times, but I am not satisfied that I have captured his true spirit like that in the pair of masks in the museum. I am convinced that an artist can only truly portray a culture he or she is living and experiencing, so maybe if I go live in the forest awhile I'd have a better chance.

I did, for many years in my thirties and forties, live by wood fire and candlelight on a small remote island. I spent a great deal of time

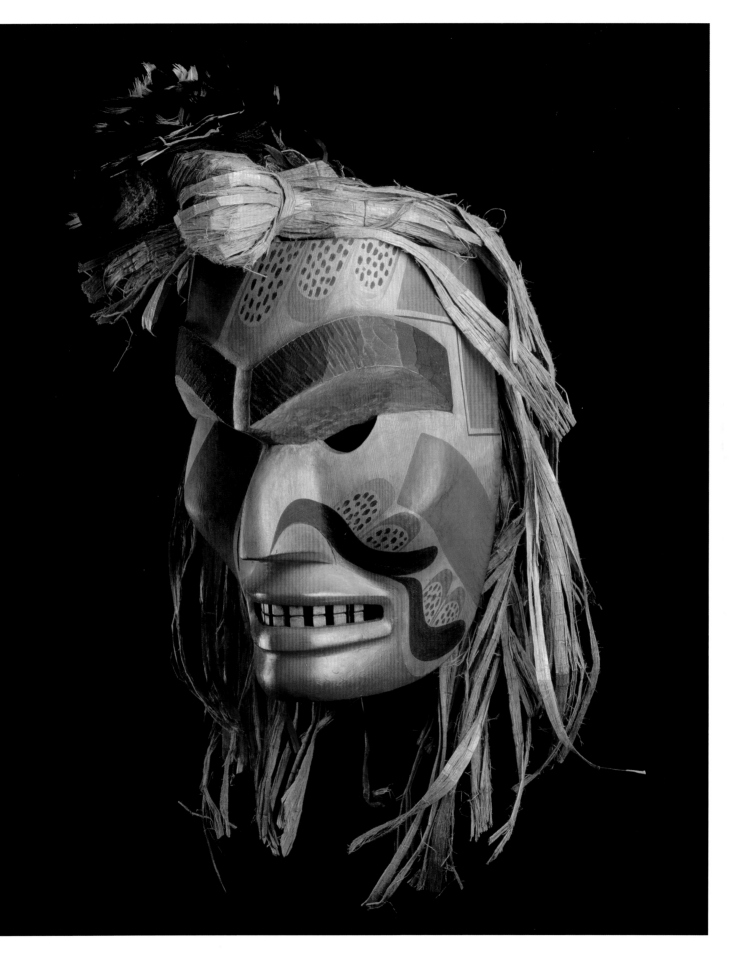

outdoors, on beaches and in the forest, silent with the animals and the birds. And during this period I created some of my most inspired art, had some of my deepest insight and felt some of my strongest emotions. And I believe I brought myself closer to Wildman, or at least I got a glimpse of a way leading to him.

My favourite impression of him is this. He is a man separated from his family and society by accident or by choice and, from exposure to harsh environmental conditions, comes to lose or discard all connections to his former world/life, all memory, period. And he has become literally his own human being, which is basically the forest/natural world made manifest. He is pure instinct, with no emotional or thought process remotely similar to his society and former lifestyle. He has become the true two-legged animal, completely adapted and totally aware of and alert to his world. He can read the actions of the forest and all of its creatures, and he can read environmental conditions such as the weather and the seasons. He is the forest, he is the forest, he is . . .

Cross-Cultural

Chilkat Moon, 2006

WAYNE ALFRED

Kwakwaka'wakw
Alder, acrylic paint
14 × 11 × 5 inches

YELLOW IS NOT a common colour in Northwest Coast art, but it does have specific associations—the moon being one, and the other is the Chilkat robe that was woven by our northern neighbours. My grandmother was Tlingit from Alaska, and I have frequently carved in this style to maintain my personal family history and to understand this style in relation to the Kwakwaka'wakw style of my home village of Alert Bay.

The moon is ancient and is commonly danced as the ancestor Emos, who will enter the Big House and slowly make his way around the room observing the relationship of families and acknowledging his approval of the ceremony (based on his long history) or watching information being handed from one generation to the next.

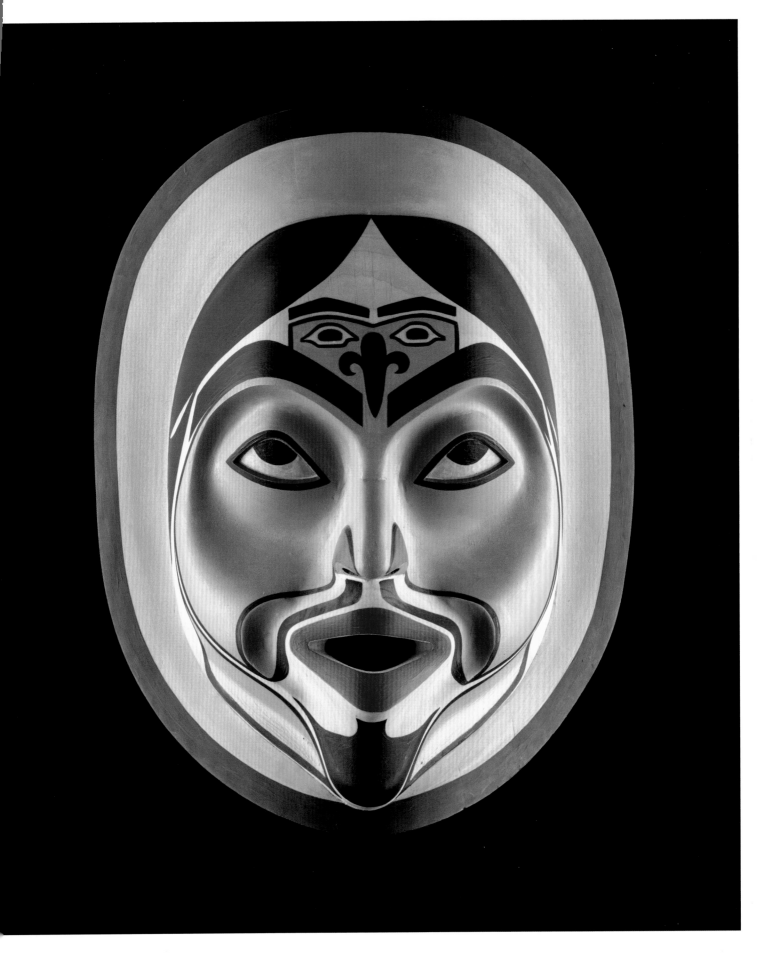

Raven Shaped Human, 2011

PRESTON SINGLETARY

Tlingit
Blown and etched glass
20¼ × 16 × 5¼ inches

THIS PIECE REPRESENTS a transformation theme. Raven, who is one of the most important animal figures on the Northwest Coast, has the ability to shape-shift. A famous story of Raven tells of how he transformed into a human to trick the old man/chief and gain entrance into his clan house. Raven had heard this man was hoarding the sun, moon and stars and wanted to get these powers for himself.

This piece depicts Raven morphing into a human. The form is inspired by a bear's tooth, and typically, these amulets could be worn as a necklace. I have highlighted the sculptural form of the tooth and exaggerated it in scale.

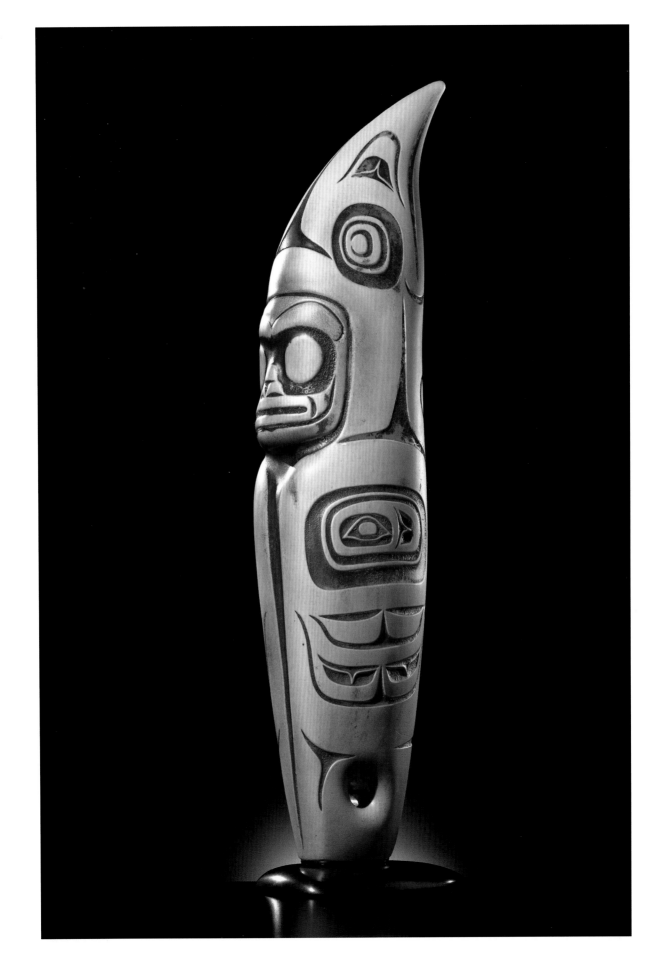

T'lina Ravenstail Robe, 2010

MEGHANN O'BRIEN

Haida/Kwakwaka'wakw
Thigh-spun merino wool, beaver fur
52 × 58 inches

I BEGAN WEAVING in 2007. Kerri Dick gave the gift of Ravenstail to me when she invited me to a class her mother, Sherri, was teaching in Alert Bay in 2008. I had no previous interest in wool weaving—I was in love with cedar bark—but the opportunity presented itself. At the time, I was living out my dream as a professional snowboarder, travelling the globe.

I began weaving this robe, titled *T'lina*, in 2009, and it was completed in 2010. I wove it under the guidance of William White, who took me on as an apprentice. During the year I wove it, snowboarding fell out of my priorities, and I eventually moved up north to weave. Snowboarding simply did not matter anymore: I could not find the motivation, and I simply couldn't value it enough to continue to invest my life in it. Something had shifted, and I understood that the work I was doing weaving was more important. This robe needed to come to life, and I needed to let go of my old life to allow it to move through me into this world.

In March of 2011 two great events occurred. I met my chief, Vernon Brown, in Haida Gwaii, and I feasted and received my Native name with my Kwakwaka'wakw family, the Wallaces, at the first cultural event we have held since 1934. I watched my grandmother Minni Johnston—a daughter of Haida princess Ruby Simeon of Kiusta and Kwakwaka'wakw hereditary chief Geoff Wallace of Cape Mudge, and a princess herself in both ways—dance the robe I created. She was honoured for being the giving, hard-working, humble and caring matriarch that she is. What I left behind doesn't compare to the fullness I feel when I attend these events and see our culture and societies strengthen. The name I received at the Wallace family feast is Kwaxilaga, which means "the smoke that comes out of the big house" and invites people to come and potlatch and feast. Smoke names are among the oldest names, as they came from the first feastings.

When I started this journey I began to wonder how far back I had to go to find the last weaver in my family. My family's Haida chief told me that my great-great-grandmother's sisters were expert craftswomen. I feel as though I have woven before and that I came back to continue my work as a weaver. I used to watch my hands, trying to understand them, before I started weaving. Now that I have found what they are meant for, my mind feels clear, like a cold winter night's sky. My spirit has centred in my body, and my life is spent in a timeless space where the past and future expand into one.

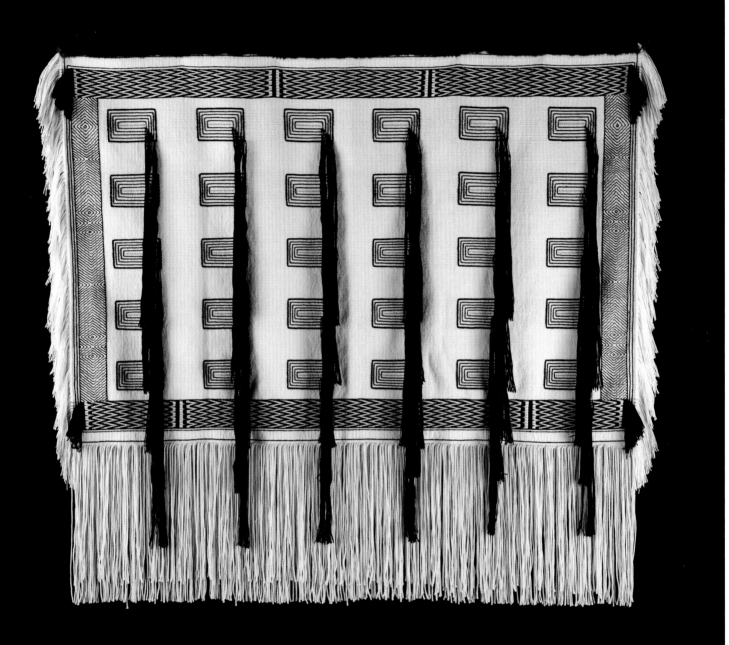

Weeping Frog Mother Rattle, 2007

JAY SIMEON

Haida/Cree

Yellow cedar, abalone, sinew, ivory,
yew wood, acrylic paint
11¾ × 5½ × 5 inches

THE STORY OF Volcano Woman is told from both the Nisga'a and Haida perspectives and links these two nations through marriage. This is only a small segment of a story involving a lengthy journey by three young men who repeatedly violated tribal laws governing the respectful use of animals and the natural environment as well as the teachings of elders who understood the history and lessons behind the laws.

The three young men had set up camp near a stream and began to fish for their dinner. A frog emerged from the forest and attempted to weave between the boys to get to the stream. The boys trapped the frog and threw him roughly back into the forest. Again the frog attempted to get to the stream and again was tossed back into the woods. On the third attempt, the boys tired of their game and threw him into the fire.

An old woman, later given the name Volcano Woman, oversaw all the creatures of the forest. Over time she realized one of the creatures of the woods was missing and set out a search. When she discovered the smouldering fire, she knew the life of the frog had been taken without purpose.

Meanwhile, the boys had returned to their village. Soon after, Volcano Woman entered the village and demanded an audience with the chief. Because of her haggard appearance she was not taken seriously, but she was persistent until one young woman, believing that Volcano Woman may be connected to the spirit world, supported her request to see the chief. The old woman requested that the boys be seriously punished for the needless death of the frog, but the chief refused, believing that Volcano Woman was crazy. She returned to the village over the next several days warning of dire consequences if the boys were not disciplined for their actions.

The young woman knew the old lady should not be ignored, but she was unable to convince the others in the village. Instead, she decided to leave, believing the village was in grave danger. The young woman walked high into the mountains and hid in caves until she heard the rumbling of the volcano near the village and the

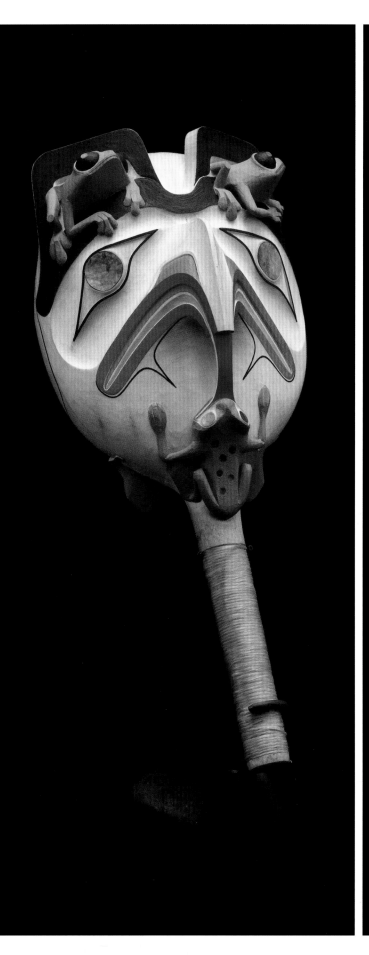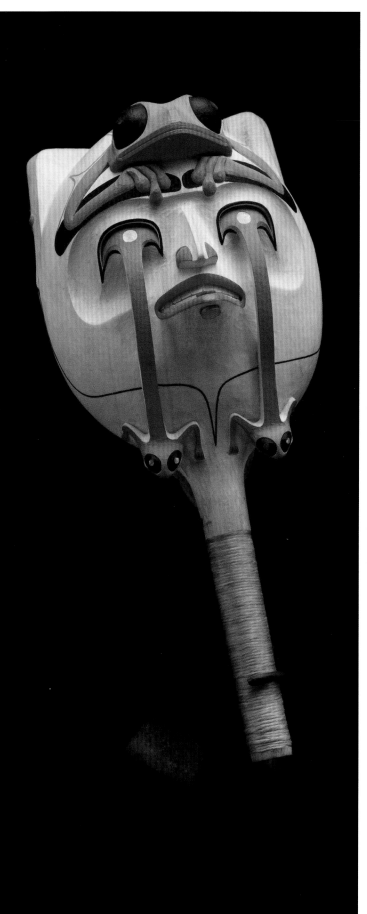

explosion of light and lava descending onto her former home. The entire region was covered in lava, which took several weeks to harden, transforming the landscape into stone for miles in all directions.

From the Haida perspective of the story, the young woman then found a canoe at the ocean's edge, made the precarious journey across Hecate Strait to the mainland and arrived at a Nisga'a village. From the Nisga'a perspective, the journey was reversed, and she arrived at a Haida village. Both territories have major lava beds to support the origins of the story. The young woman married into a family in her new village and had several children. The children were raised to early manhood, when

she decided to take them to the site of her home village to see her origins and to allow them to lay claim to crests and privileges held by her family.

A small community had reformed following the devastation of the volcano. The children decided to stay in the woman's birth village, and she made the return trip to her adopted village alone.

This story continues to link these two nations, and many families have claims to the lineages and crests formed from this marriage.

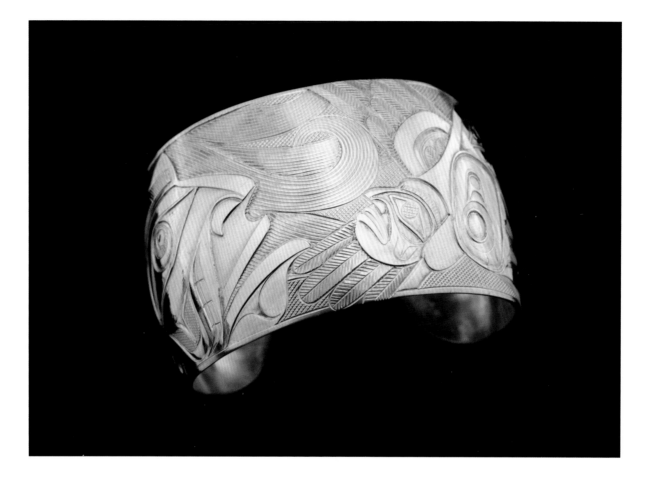

Love of Shiny Things, 2007

SHAWN HUNT

Heiltsuk
18-karat gold
1½ × 6 inches

I DON'T DO a lot of gold jewelry because I fell in love with the look of oxidized silver, which gives me a colour to work with, to create contrast. So when I started this piece, my first thought was that the person who wears this bracelet really has to love shiny things. (It's quite a bit of gold.)

Pictured on the bracelet is Raven (also a lover of all things shiny) flying off with a woman's earring. I thought it was kind of a modern take on an old myth, Raven steals the light, only in this case the new light is now a shiny piece of gold. The stories of Raven are part of the entire history of the Northwest Coast art form, including today, and Raven playing havoc with the modern world would invite an encounter with a gold earring.

Grizzly with Eagles, 2003

STAN BEVAN

Tahltan-Tlingit/Tsimshian
Alder, horsehair, operculum shell, acrylic paint
14 × 10 × 7 inches

WE ARE NORTHERN wolves from the territory along the Taku
and Stikine Rivers. We also have the rights to use the Grizzly and
Eagle names. Our family names originate from our Tlingit and
Tahltan grandparents.

My ancestors gathered food in the same places as the grizzly
bears and eagles. They would speak to the bears and let them
know they wanted only to share the salmon and meant them
no harm.

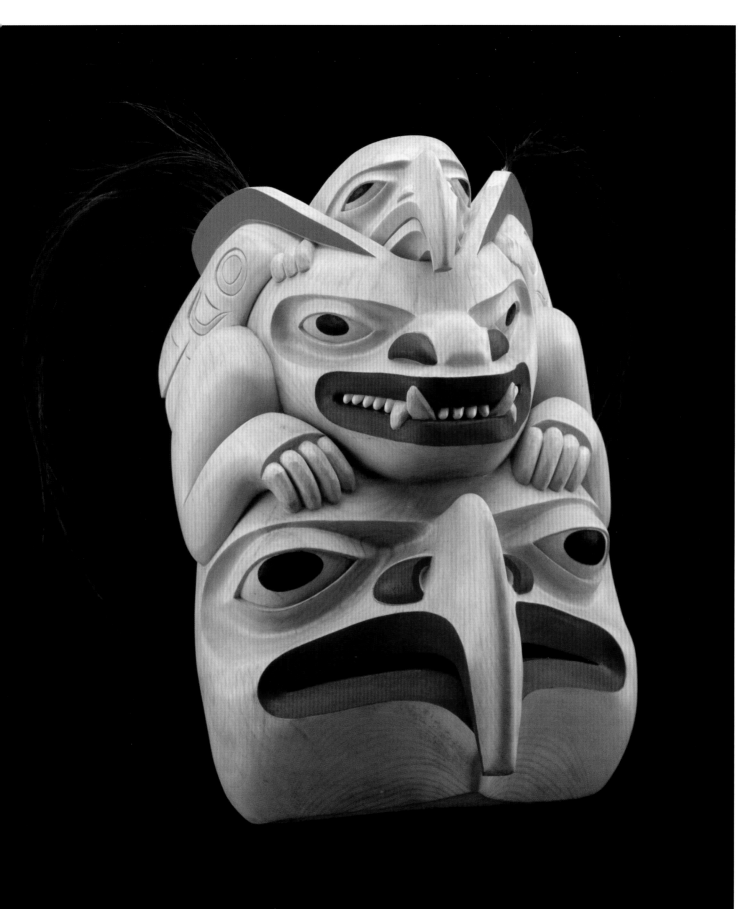

Form-line Revolution
Bentwood Box, 2008

COREY MORAES

Tsimshian
Red cedar, operculum shell, acrylic paint
27 × 19 × 19 inches

REVOLUTION, BY ITS definition, means "a sudden, complete or marked change in something."

I intended this box to challenge the veritable norms of present formline rules or guidelines. My purpose was to create a design that not only is aesthetically pleasing but also presents formline in a new light, something that I strive for in all Northwest Coast–themed works. My desire to present an ancient form in a new, varied structure is what drives my ambition around this art form.

I wanted this piece to celebrate the three basic techniques of bas-relief formline—carved, painted and carved, and just painted. In so doing I also wanted the completed work to take on an abstract quality, while upon closer inspection revealing a standard corner-oriented box layout, separated by the different bas-relief approaches.

Whether it's in sculpture, graphics or precious metals, I am challenged to create this ancient art form in new, relevant ways. I want to make the art relatable to today, because that is the life I'm living. Just as the masters of old created for their era, interpreting what were current topics to them then, my desire is to utilize what I've experienced and what goes on around me now.

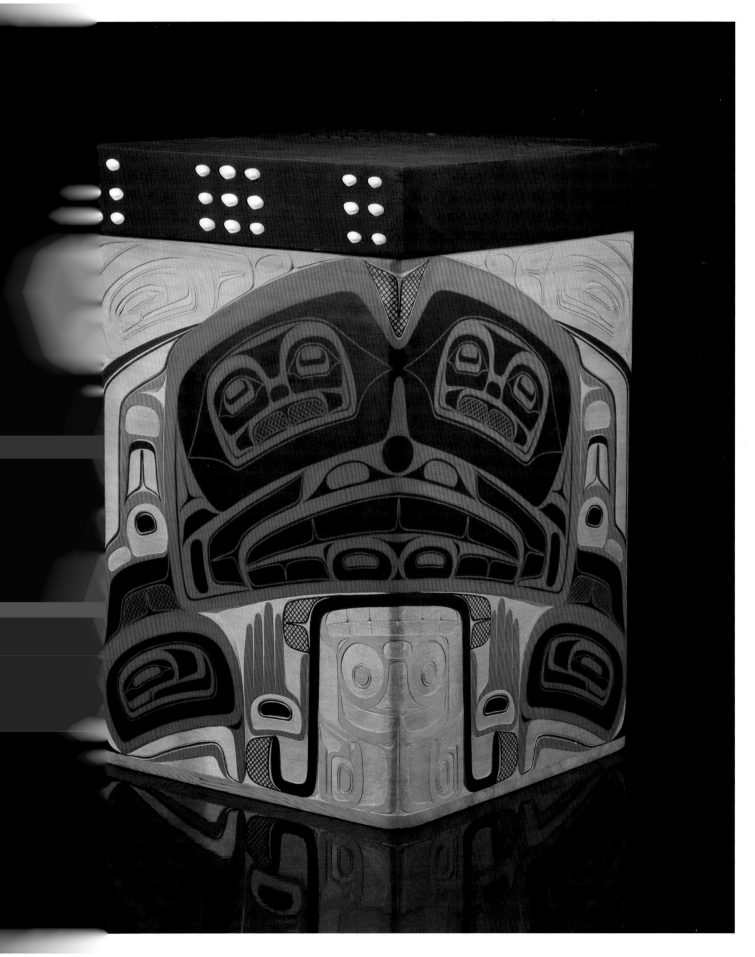

Children of the Earth, 2001

SUSAN POINT

Coast Salish
Yellow cedar, etched and blown glass
56 × 34 × 5 inches

THE PACIFIC SPIRIT RUN, a 10-kilometre (6.2-mile) run through the University of British Columbia Endowment Lands (Pacific Spirit Park), was an annual fundraising event for local hospital charities. It continues today, though it has been renamed. The first year I did a design for the run was in 1990, so 2001 was the twelfth consecutive year I supported the event by designing this signature image to be used for fundraising purposes. Each year I produced a limited-edition print of the design, and on a few occasions, an original acrylic painting. In 2001 I produced this design, *Children of the Earth*, as a limited-edition serigraph. I continue to support the evolving foundation's work with an original design every year.

As with all previous images for the Pacific Spirit Run, *Children of the Earth* relates directly to the event. The design also represents motion and the feeling of peoples coming together to achieve a common goal. The four different human faces represent multicultural diversity and illustrate our connection and the common thread we share.

To explore the image further in more dimensions, I carved a yellow-cedar spindle whorl of this same image and combined it with glass components to emphasize the meaning. I believe we are all children of Mother Earth, "One Family," and I hope this message is visually conveyed through my imagery. The red glass dome in the centre of the piece represents the bloodline of all peoples, as do the forms spiralling from the centre of the faces that represent humanity from all four corners of Mother Earth.

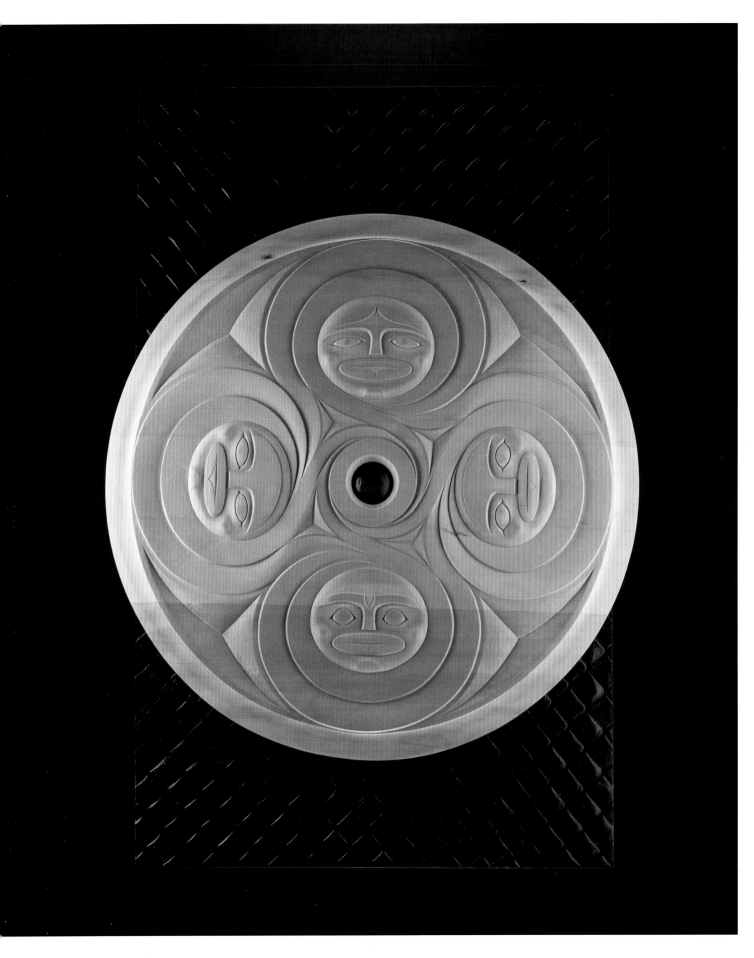

Raven at the River of Mist Headdress, 2003

KEN MOWATT

Gitxsan
Birch, red cedar, copper, feathers,
ermine tufts, deer hide, acrylic paint
13½ × 18 × 8 inches

RAVEN REMEMBERED WHEN his feathers were pure white and when they glowed a dim red from the reflection cast by the sulphur-smelling fires of the young earth. It wasn't pleasant then, but you could always find a warm place to rest, thought Raven. He wasn't happy with his present black, scorched feathers, but he had survived the clapping mountain. That incident had occurred so many millennia ago, and Raven still wondered why he accepted the challenge made by the large, monstrous beasts. It was obvious that to this day they hadn't made it across the fires of the mountain. As Raven flew along the vast waters of the west coast he wondered if the beasts had meant to get rid of him. This new land, he thought, is no prize. The landscape is barely visible. It is dark most of the time and wet. Raven had not seen or heard or encountered anything different for so long that his weariness had begun to weigh on him.

With the spirit like that of any living thing that is burdened, Raven sat and reflected. Raven revisited his origin, the place of his ancestors where light and colour played harmony to the spirit, its peacefulness balanced by pure shapes and form. He heard the voices of his parents and elders saying, "Your journey is not of doom but of adventure and discovery, so be patient and wise. You must carry on the breath of your ancestors." Raven spread his wings and went about his way. He came to a large river, which he followed north. Raven found the going up the river difficult; with so little light it was very hard to see past the mist. As Raven contemplated turning around, he faintly heard the beat of drums and singing: "Hey, hey hey—give us more light so we can serve you better, hey hey!" Raven was soon to meet his first people and begin his adventure of the River of Mist.

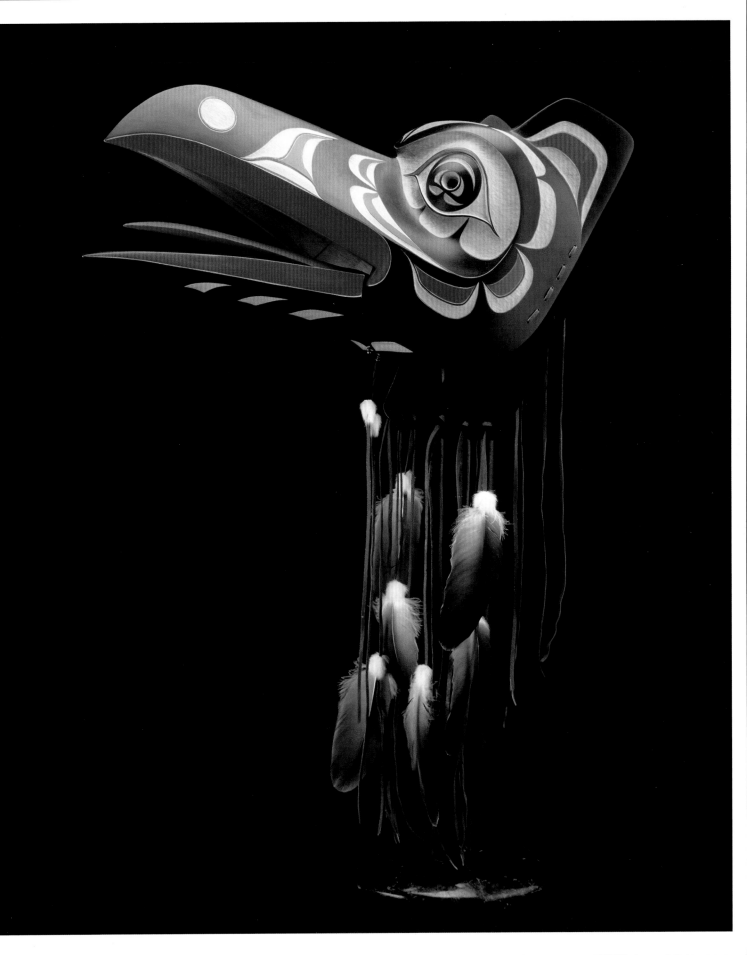

Weeping Frog Mother, 2011

FRANCIS HORNE SR.

Coast Salish
Spalted alder, abalone shell, wax
24 × 13 × 10 inches

THE STORY OF Weeping Frog Mother was told by northern tribes and recounted the interconnection of all living things and the need to understand how all of nature's elements relate to each other. The Frog Mother, or Volcano Woman, is often unkempt and dressed in rags, but she has a noble presence and she knows everything about the realm of the forest.

I have carved numerous variations of this mask and have always been attracted to the technical aspects of carving out the frogs so that they float like links in a chain. I also like to play with frogs or, in this case, the abalone tears flowing from the eyes—a precarious detail to capture on a thin base of wood that is floating away from the face.

Spalting alder means allowing the wood to rot slightly, using heat and moisture until the grain begins to run. Although this technique can be used with softer woods like cedar, the wood becomes porous like weathered bone. Alder, being a harder wood, can be controlled so that the streaking is prominent, but the wood is still strong and able to hold detailed carving.

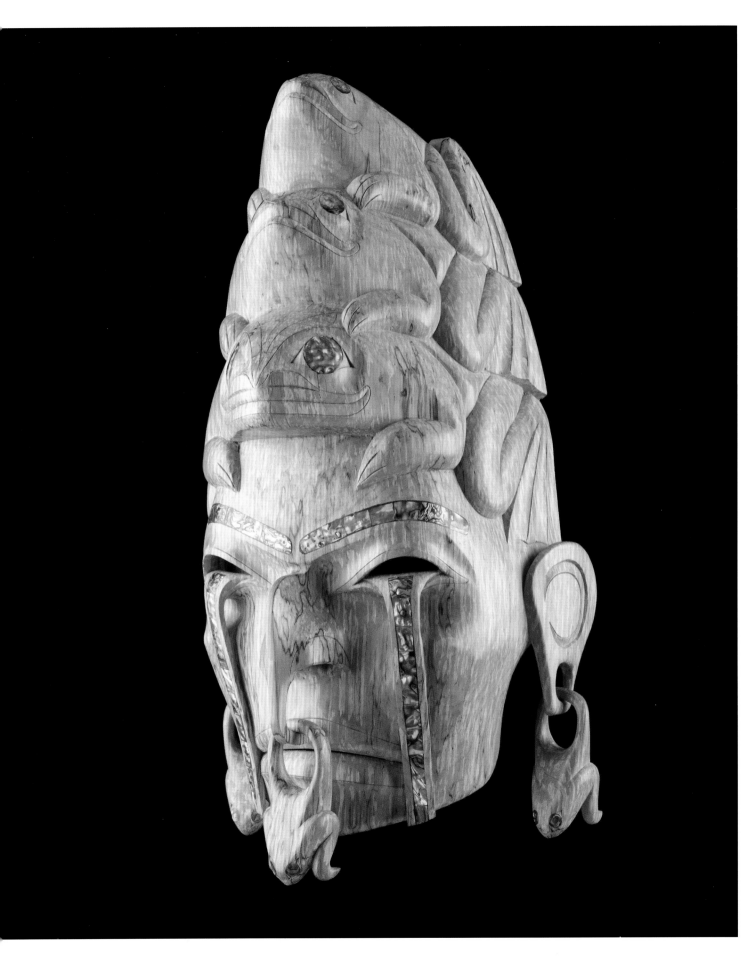

Bahgwanah—The Origins, 2003

LYLE WILSON

Haisla
Acrylic paint on red cedar planks with
traditional yew wood butterfly repairs
72 × 52 inches

WHERE DID THE shapes of the Pacific Northwest Coast painted arts originate? This question has perplexed many people—myself included—who are interested in the history of this complex art style. The formlines, U shapes and ovoids that characterize Northwest Coast art are basic formal elements whose origins are undocumented. Despite an extensive written body of scholarly work, these elemental Northwest Coast shapes have retained their mystery and reside in the background of artistic and academic sensibilities. Early European collectors, such as Lieutenant Emmons and Judge Swan, briefly refer to them, with Swan's 1874 reference to the origin of the ovoid linked to the eye-spots of a young skatefish being the most relevant to this story. For an artist like myself, it was a powerful attraction to ponder the beginnings of such an important shape that is shrouded in such mystery and so lacking in information.

I grew up in a hunting, fishing and gathering lifestyle, as opposed to the theoretical models of most researchers. Later, I attended a university and an art school, both of which instilled a love of books and logic. For a Northwest Coast artist this is an unusual background, which sometimes gives me an unusual or fresh perspective when I tackle projects. My background definitely helped shape this painting. During my university years, I barely remember reading the Swan reference citing the skatefish-ovoid theory. Although I've caught a few skatefish while fishing, I didn't remember any ovoid-like spots on them. Years later, an uncle took me food-fishing for halibut. My uncle, who over the years learned to indulge my odd, big city–acquired notions, was probably puzzled at my enthusiasm when we caught a skatefish. I explained my reasons, and he told me the Haisla term for the creature is Bahgwanah. This particular specimen did have two small spots on its wings, but they were nothing like any ovoid I was familiar with. With disappointment, I dismissed this bookish theory.

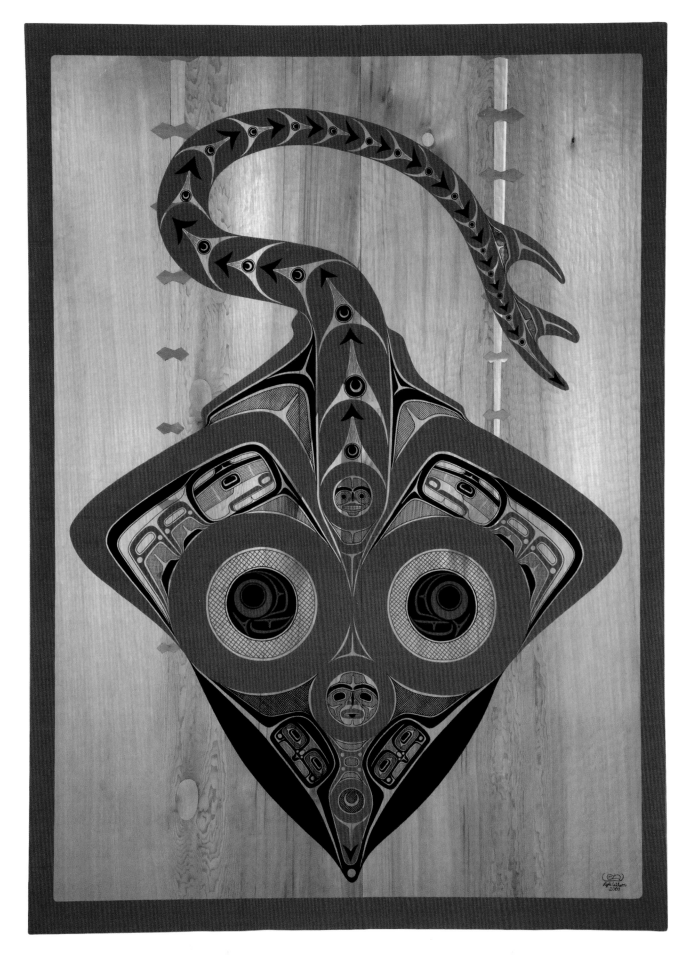

Much later, in another book, a photo of a skatefish that had large circular spots with fine lines encapsulating them quickly revived my interest in the skatefish-ovoid theory. Apparently there are several species of skatefish, and we simply caught the wrong species on that earlier fishing trip. The final piece of the puzzle fell into place when I witnessed a modified skatefish egg sac at the Vancouver Aquarium. The egg sac had a small transparent patch, which allowed viewers to peek at the live specimen contained within. The wing of this young one had eye-spots that were more defined than those of an adult skatefish, and that defined ovoid would have been entirely at home if it was possible to remove it and put it in any of my paintings. Needless to say I was thrilled to see Swan's reference right in front of me.

The classic ovoid has an underlying, more rectangular format than the skatefish's circular eye-spots. The difference is substantial enough to cast doubt on the link between the skatefish and the classic Northwest Coast ovoid. The important link, in my mind, is the fine line that encloses each. It is a delicate detail that balances the power of the painted ovoid. I've developed a plausible evolutionary sequence for the difference in shapes between circular skatefish eye-spots and the man-made painted ovoid, as well as some of the other Northwest Coast art elements. Regretfully, the full story cannot be told here. For now, I'm fully convinced the link between the skatefish and the ovoid is real. *Bahgwanah—The Origins* is my tribute painting to a strange creature that helped shape the art of the Northwest Coast.

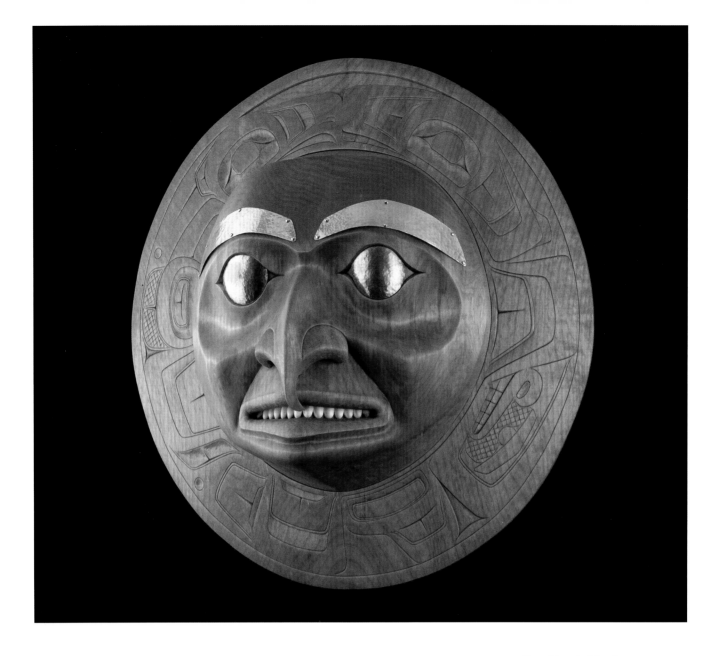

Sun Hawk Mask, 2001

**NORMAN TAIT
AND LUCINDA TURNER**

Nisga'a
Alder, copper, paint
20 × 20 × 9 inches

THE SUN HAWK is a crest of a tribe from Alaska that dates back many centuries and came to the Nisga'a through my father's family. The design on the rim identifies the family owning the crest. The number of rays indicates the family's lineage based on its hereditary position in line for the chieftainships.

Butterfly Headdress (Sdla k'amm), 2003

ROBERT DAVIDSON

Haida

Red cedar, cedar bark, acrylic paint

10 × 20½ × 9 inches

IN HAIDA MYTHOLOGY, creatures often travel in pairs to bear witness and document the exploits and experiences of the journey. In the north, Butterfly is the travelling companion to Raven, and in the south, Eagle and Raven travel together.

In more recent times, Butterfly has become the symbol of repatriation. When objects and human remains are returned from distant institutions for reburial in their home territory of Haida Gwaii, Butterfly is overseer and protector, and witness on their journey home.

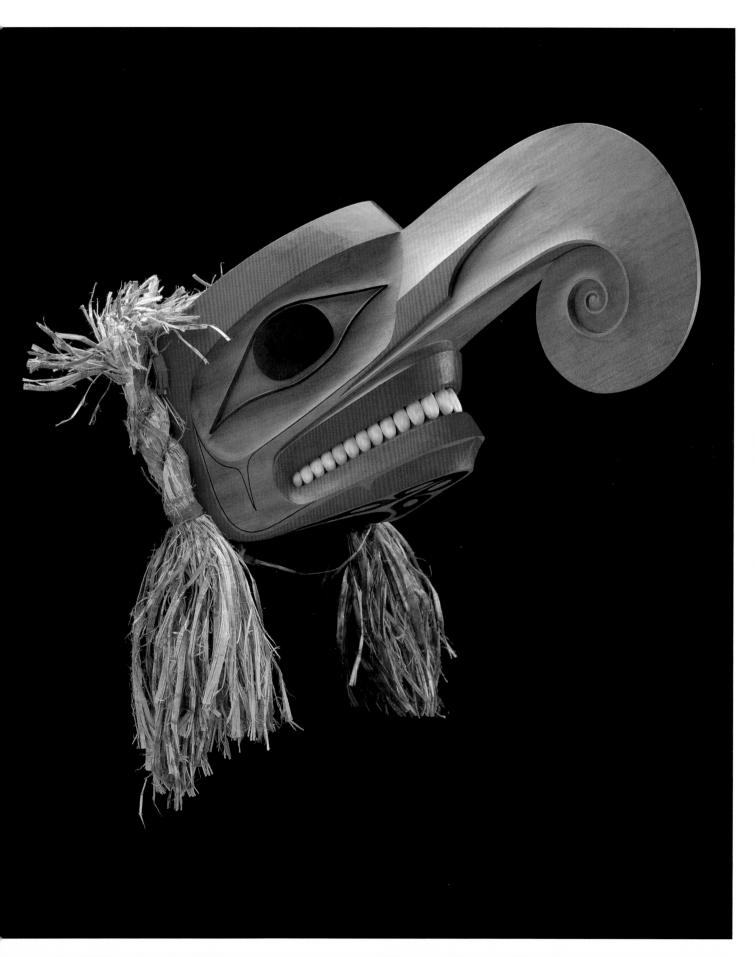

Raven's Nest Basket, 2008

WILLIAM WHITE

Tsimshian
Merino wool, cedar bark
5 × 4¾ × 4¾ inches

IN THE PAST a chief would have one of his robes cut into pieces and distributed at a potlatch. He would give the pieces to his most esteemed guests. The recipient would collect as many of the cut pieces as he could and have them fashioned into a piece of regalia. Other chiefs would see the new regalia and know they were looking at someone who was held in high regard among his peers. My sister and I have cut up an apron and we have distributed the pieces; in fact, one piece was presented to Maori artist Darcy Nicholas, to thank him for looking after me while I was in Aotearoa (New Zealand).

The Chilkat basket is inspired by an old hat that I once saw in a museum collection. It was a cedar-bark hat completely covered in cut Chilkat fabric pieces. These pieces had been collected and sewn onto the hat. One night I decided that I was going to make a basket, but instead of using bark or roots, I used wool. The designs on the basket represent the wings of a raven—they surround the piece and are reminiscent of my granny's arms wrapping around her family. Her name was Wii'n Loolth Gaax (Great Nest of the Raven). The basket is a combination of basketry, Ravenstail and Chilkat weaving techniques. The name of the piece is *Loolthm Gaax* (*Raven's Nest*).

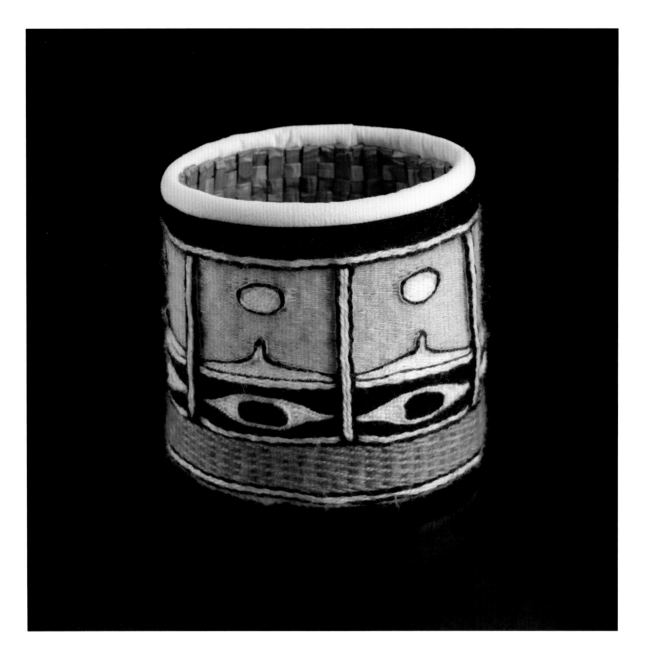

Raven and Family Sculpture, 2000

CHRISTIAN WHITE

Haida

Argillite, catlinite, abalone, mastodon ivory

13 × 6½ × 4 inches

THIS SCULPTURE WAS a commission to honour the birth of a daughter. Raven Yaahl, Xuuyaas, the trickster, the transformer—he had all the attributes of a human being, good and bad.

As Raven flew over an endless sea, he saw a two-headed kelp on the surface. He landed on the kelp and began to climb down beneath the sea. He discovered as he climbed that he was descending a two-headed totem pole. When he got to the base, he saw that he was in front of a house. He stuck his head in the doorway, and a white bald-headed man (Seagull, in human form) said, "Grandson, I have been expecting you." The man gave his grandson, Raven, two stones, one speckled and one black, and said,

"When you get back to the surface, put the black stone in your mouth and spit it toward where the sun rises. Take the speckled stone and spit it to where the sun sets." Raven went to the surface and in his haste spit the stones in the wrong directions. The speckled stone became the Americas, and the black stone became Haida Gwaii. That is why Haida Gwaii is small.

When Haida Gwaii started to rise out of the ocean, Raven spied a large clamshell, and in the shell, he saw there were humans—Raven's children. Raven was the catalyst for change: the human beings learn from his travels and experiences. There are many stories of families being blessed by the birth of a child. Sometimes this miracle comes about with supernatural intervention.

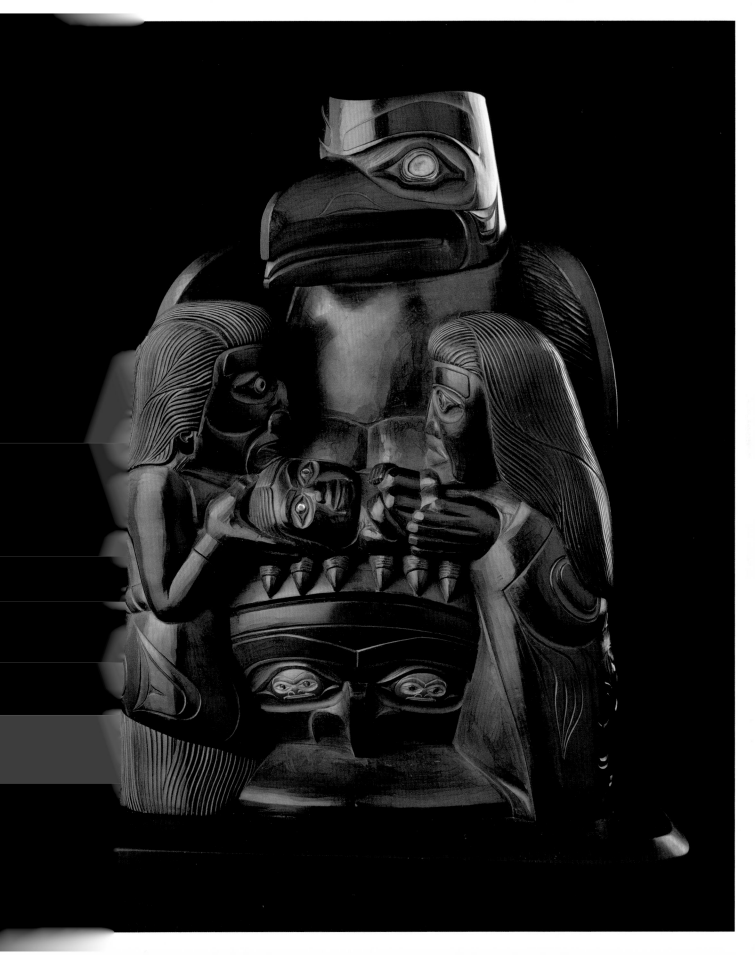

Swan Bowls, 1997 (cygnet)
and 2000 (Mother Swan)

NORMAN TAIT AND LUCINDA TURNER

Nisga'a
Alder
8 × 6 × 7 inches (cygnet)
and 18 × 14 × 12 inches (Mother Swan)

THE SWAN BOWL came from a distant tribe, possibly Alaskan, and to our family through my father's family. I started this piece six years before it was completed. Lucinda Turner found it in the attic, and she loved the form and we decided to finish it. Over time, we tried several variations and played with the gosling version, which worked well on the smaller scale.

Bowls had many uses for the Nisga'a. They could be positioned at the entrance to a ceremonial hall and filled with eulachon grease, which was an indication of the wealth and power of the nation or of the individual members of a family crest. Guests would then dip pieces of salmon in the grease as a form of welcoming and cleansing. Bowls were also important gifts to honoured guests, who would be given carved bowls by major artists as a token of respect or payment for witnessing and participating in the ceremonial feast. A feast would often be given by members of an individual family crest to officially pass down a historic name, which defines the rank and standing of its recipient. The name is called out three times by high-ranking elders to strengthen its importance, and valuable gifts reflect the status of the caller. Bowls were also used to serve food during a ceremony.

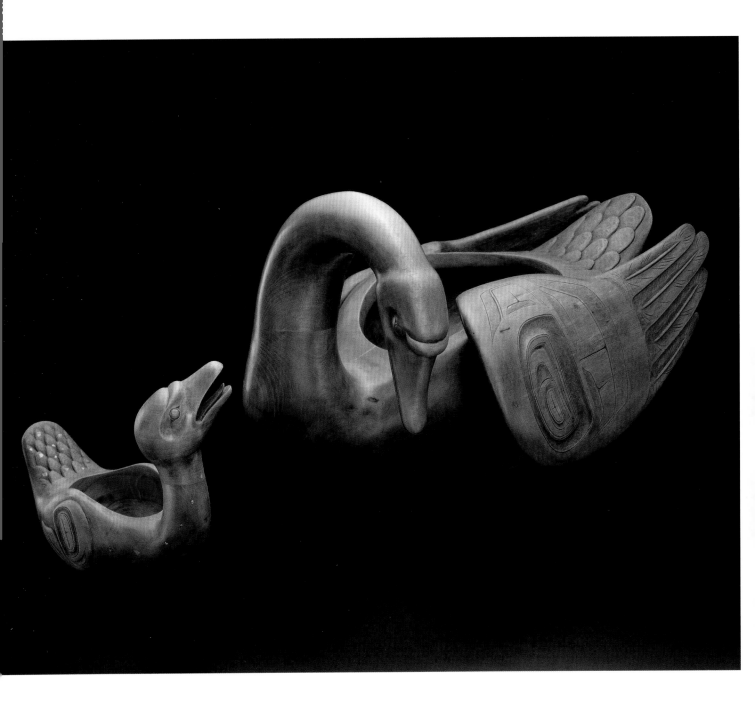

Killerwhale Crest Mask, 2007

KEITH WOLF SMARCH

Tagish/Tlingit
Birch, acrylic paint
22 × 12 × 7 inches

KILLERWHALE IS MY primary crest, known as Dawklawedi. I am an inland Tlingit though, so I knew very little about the whale until my grandfather took us each summer from the mining village where I grew up to a fishing village where he would tell us stories every night. He was a coastal Tlingit from Juneau, Alaska, and my grandmother was Tagish—inland Tlingit.

My grandfather told me that I should always depict the whale breaching with his head high, as a sign of life. We were also told that when we were on the water and saw the whales breaching, we should turn away when the tail is about to submerge, for luck and as a sign of respect.

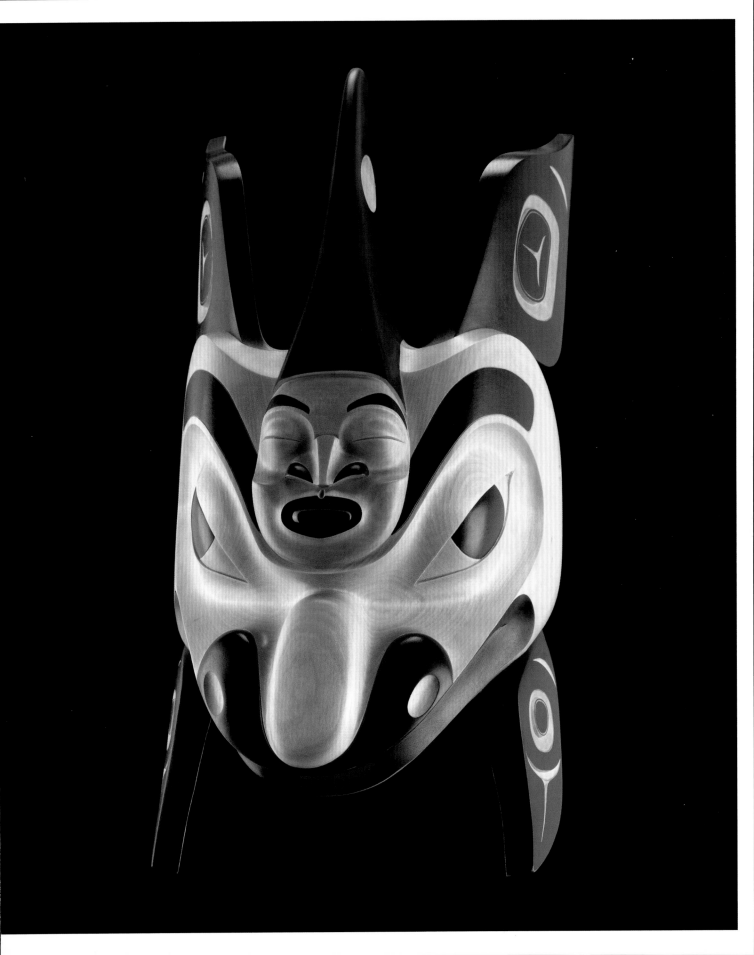

Cradle Board, 2001

ART THOMPSON
WITH MARTIN MACNUTT

Ditidaht/Nuu-chah-nulth
Red cedar, beads, cedar bark,
metal tacks, leather, fabric
40 × 15 × 5 inches

CRADLE BOARDS WERE used almost universally across North America. The basic form allowed for freedom of movement for the mother or wearer and safe, snug protection for the infant. They were used traditionally during long hauls over rough terrain as well as in daily chores such as gathering plants and berries and cooking, and they provided some assurance that the infant would be protected in the event of a fall. Cradle boards continue to be used today because the design remains effective.

Some of the designs were quite simple and others highly elaborate, their artistic range being distinct both tribally and by individual artist. Plains artists have explored the cradle board at the highest level, with elaborate carving and beading; it is rarely seen as an art object, however, among the Northwest Coast tribes, so I was excited to make one. I carved the piece in my style and using Nuu-chah-nulth forms, and then I invited my cousin Martin MacNutt to create the beaded designs. These added a new dimension to this Northwest Coast object and made it more universal in design.

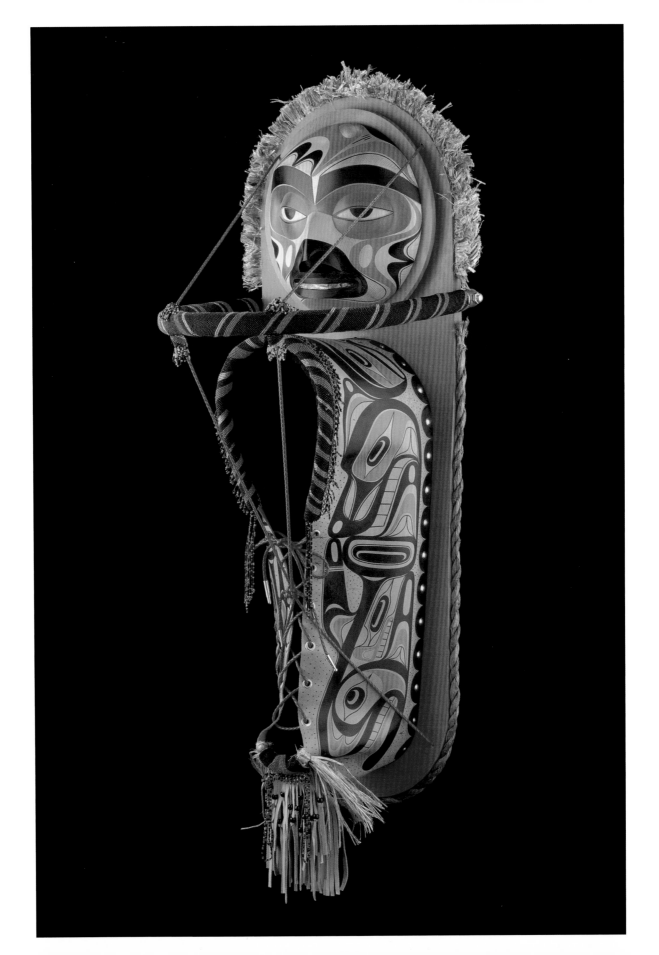

Medicine Man Pendant, 2010

LUKE MARSTON

Coast Salish
Chased, repoussé and engraved silver
2¾ × 2 inches

I STARTED THE medicine man right before I went to Italy to work with master silversmith Valentin Yotkov. At that time I was using the jewelry-making techniques I learned from Robert Davidson, though I did bring this pendant to Italy to get Val's input on the piece.

All of the figures I put on this pendant—Frog, Owl and Serpent—have to do with medicine. The shaman would use the help of each animal to enhance his power and connection to the spirit world. (Throughout history, Salish artists have known this and shown it on pendants, boxes and stone bowls.)

On the forehead is Frog, who helps the shaman to travel into the spirit world to retrieve lost souls. Frog also brings cleansing medicine, because it is always in and out of the water cleansing itself. Bathing is a common tradition for spiritual preparation that is still done by some people today.

Owl, on the chin and lower face, is always related to doctors and medicine, especially its calls in the middle of the night that sound like a calling baby and its silent flying in the dark that brings a feeling of the supernatural. The Shaman uses Owl's feathers and bones to make regalia, which in turn possess Owl's abilities.

The two serpents on the sides of the pendant are supernatural: they are thirty feet long and live in the rivers, lakes and streams. Serpent is also related to the traditions of bathing and using the power of water to heal and cleanse. Some medicine men traded with the interior shamans for rattlesnake venom, which they would smoke in little bits to induce hallucinations. Some also used the venom to perform black magic and poison people, to instill fear in others and show how powerful they could be. This is why we find rattlesnakes on some of the stone bowls that were found on Vancouver Island.

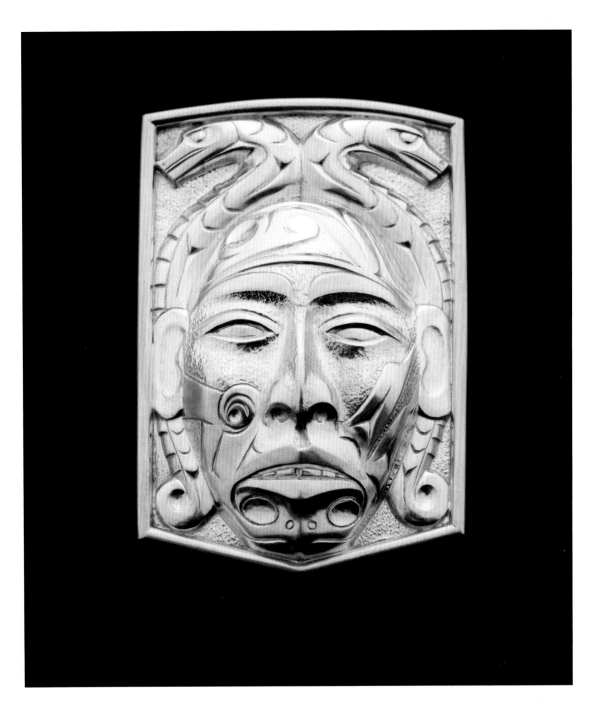

Eagle, 2010

WILLIAM KUHNLEY JR.

Nuu-chah-nulth/Ditidaht

Red cedar, cedar bark, acrylic paint

16½ × 17 × 17 inches

DESIGNING AND UNDERSTANDING Northwest Coast formline is a skill requiring many years of practice and study, and artists who have served an apprenticeship under a master artist know it involves a process of transformation. It requires not just skill in carving and painting but also an understanding of yourself and a dedication to the craft. Artists, then, are not simply carvers; they breathe life into each piece and pay respect to the subject as well as to the chief who found them worthy of the commission to make the best possible piece.

Artists never stop learning, exploring and discovering, as well as pushing creative boundaries and looking for new ideas. Ten years after I completed my apprenticeship I still show my pieces to my mentor, Robert Davidson, for his opinion, knowing that I have taken them the distance in terms of finish but continuing to learn that there is always one more step.

This mask is knife-finished without sandpaper, which shows a high level of expertise and intentionally makes a statement of perfection. This technique is not only a surface treatment but also reveals a complete understanding of the planes and overall form, the undercuts and finish of the details. To this sculpted surface is applied a formline design, which must wrap around the shapes, create tension in the design and define the character being represented. In this mask I have chosen Eagle as my teacher.

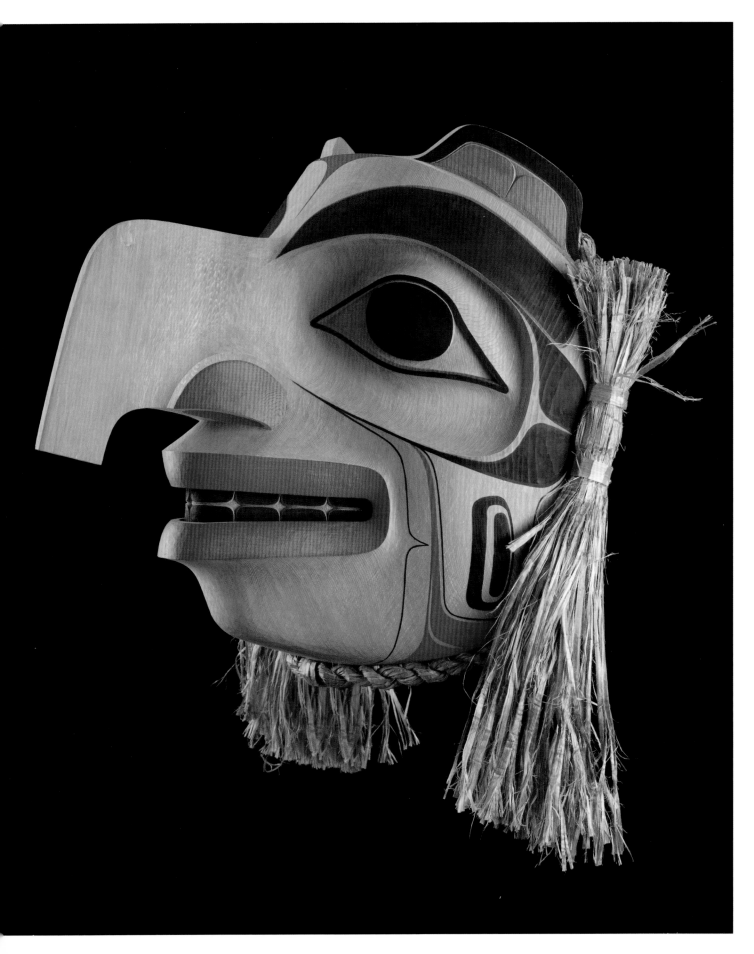

Ehwep Syuth
(To Share History and Culture), 2007

JOHN MARSTON

Coast Salish

New Guinea rosewood, yellow cedar, black
walnut, ebony, acrylic paint, red cedar bark
78 × 44 × 5 inches (excluding base)

FOR ME THIS carving is a symbol of connection between different cultures, especially our patience with and understanding of one another as well as our willingness to help and our kindness in sharing tradition. *Ehwep Syuth* also reflects the value of taking time to look deeper, to truly understand people.

When I first began to envision and create this piece, I knew for certain that I wanted to reflect what I experienced and the emotions I felt while taking part in a cultural exchange on the Sepik River in Papua New Guinea. During the process of making it, though, the concepts within it became a celebration of both cultures, and of nature and design. My reason for creating a work of such complexity is to tell a story that I lived and was part of.

Design was the first aspect I contemplated, as the piece progressed and evolved. The concepts had to be representational so that they remained clear in a larger emerging context.

First, the suns and the moons on either side of the carving are placed in opposing positions to symbolize the two cultures, Canada and Papua New Guinea, that are geographically a world apart but similar in so many ways. Four face masks carved from New Guinea rosewood are set beneath the yellow-cedar suns and moons and can be viewed only while looking in through the negative space that has been removed. These partially hidden masks embody the people found within the diverse cultures. The presence of two face masks on either side, symbolizing the balance of male and female, reiterates the importance of balance in ceremony.

The design of the panel depicts many different animals found in Papua New Guinea and Canada. These sacred animals are found within positive and negative space. The head, eyes and mouth may appear in negative space, while the wings flow off these lines into positive. Colours change, but forms continue to stay together. Highlight painting introduces a glimpse of the design changing but also holding other forms.

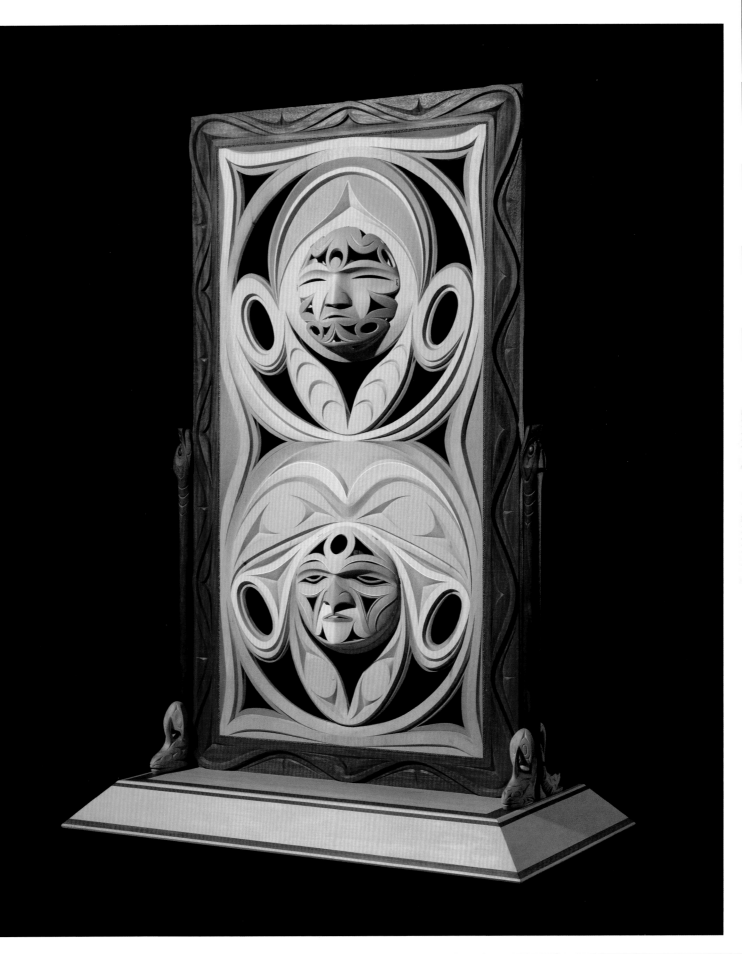

The supporting posts carved from black walnut are Sea Wolves, the guardians of land and water. The pins that support the centre panel are carved from ebony in the shapes of Snakes and Salmon. The carved rosewood border symbolizes our connection with water and also our connection to the forest. Our ways of life rely heavily on the ability to connect to these sacred places. Also within the border are black walnut inlays in four areas, which represent the four directions that are an important part of our ceremonial life.

Influences from Papua New Guinea include the brighter pigments, which are direct tones found within the land. The Killerwhales and Crocodiles at the base of the posts are reinforcements; they are supporting one another and have become brothers, reflecting the role these creatures play in both nations' historical legends. Finally, the finely braided cedar-bark rope symbolizes the connection and ties that have bound the cultures together. The significance of weaving to each culture is an aspect that speaks to the very core values and beliefs of both people. The presence of bark, between the yellow-cedar and rosewood framing, is also a traditional symbol of respect— that is, showing the connection these two elements once shared as a sacred tree, growing, caring and protecting one another.

Contemporary

Hawkman and Child, 2003

RICHARD HUNT

Kwakwaka'wakw
Red cedar, acrylic paint
25 × 13 × 11½ inches

HAWKMAN IS A mythical being, half hawk and half human, that is mostly seen on frontlets and as the central face in sun masks. Frontlets are chief headdresses that carry family crests and are worn at ceremonies both locally and when the chief is invited to share in the ceremonies of other villages. When they are danced in ceremonies, sun masks are held in front of the face as a large prop rather than as a mask worn over a face.

Hawkman is the liaison between the sky kingdom and the human world, and he travelled freely between both worlds, connecting the Sun, Moon and sky creatures to the creatures on earth. In time, some of these sky creatures took human form, or marriages occurred between sky beings and humans, creating a powerful lineage in both worlds.

Hawkman represents a family allegiance to the people of the sky, earned by ancestors and adopted as a family crest. My father, Henry Hunt, carved sun masks with a human face, a hawk's beak and human lips, and my ability to use the hawk comes from my dad. I've put a baby Hawk in the form of a man on the Hawkman's head. Note this mask's moveable bottom jaw.

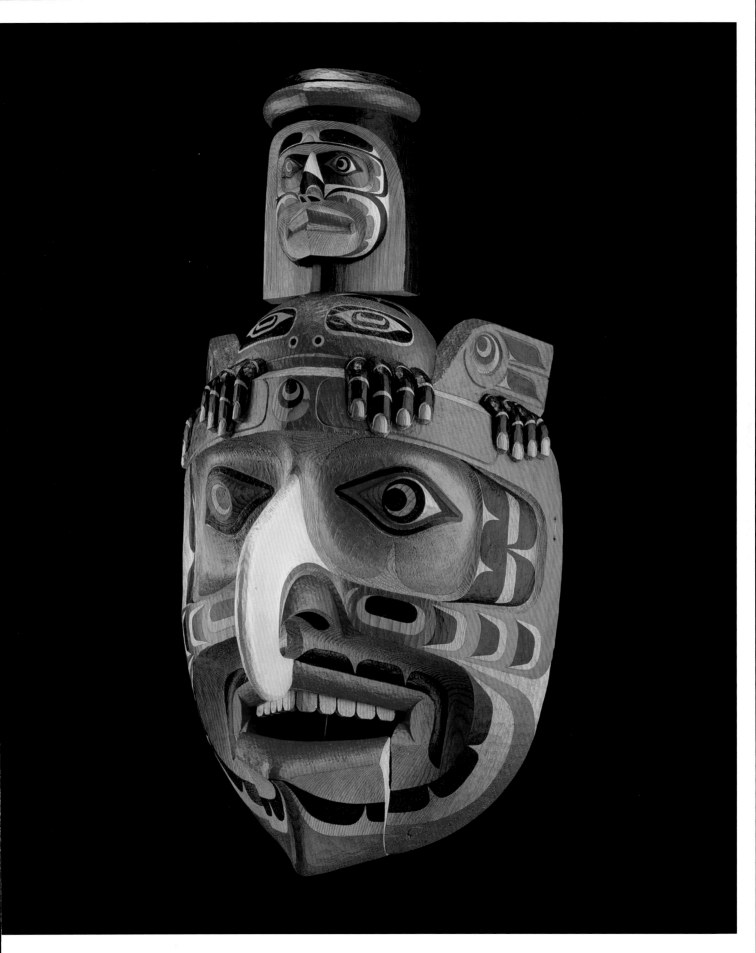

War Boss Panel Mask, 2011

DEMPSEY BOB

Tahltan-Tlingit

Yellow cedar, operculum shell, acrylic paint
18 × 16 × 5 inches

EACH CLAN HAD a warrior who would lead in battle. The respect for this warrior was immense, and in battles between clans, the outcome was often determined in a fight between rival warriors rather than in a large-scale battle.

This warrior is wearing a helmet that represents his history and his Grizzly Bear Clan. Warriors would wear helmets that told of their history, families and accomplishments, including their success in previous battles. A human form is carved on the visor.

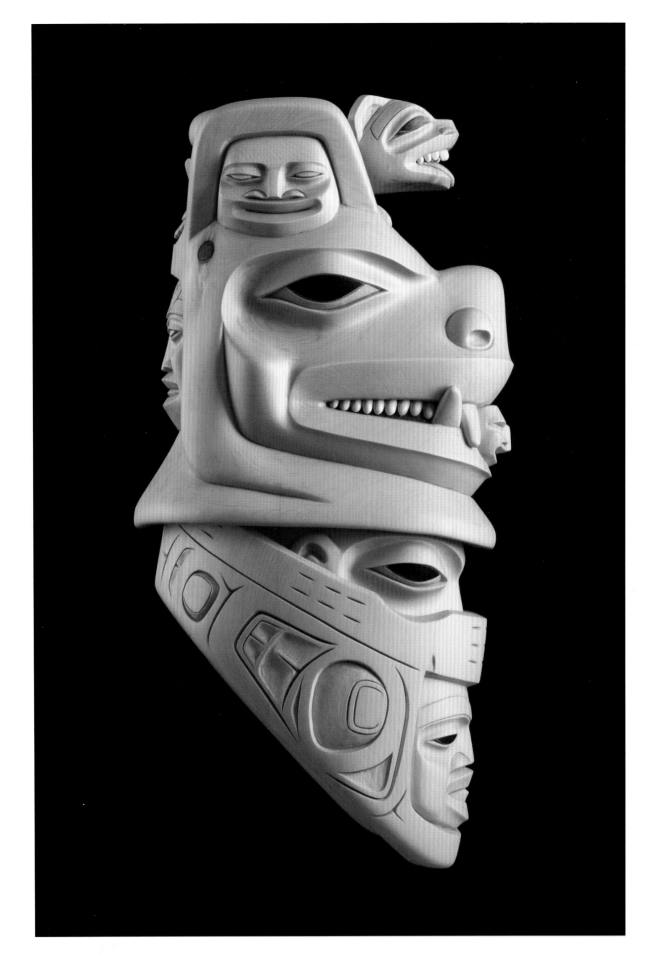

Spirit of the Whales, 2000

FRANCIS HORNE SR.

Coast Salish
Red cedar, acrylic wash
28 × 29 × 26 inches

THE MAKAH AND the Nuu-cha-nulth have a long history of hunting whales. Immediately after a hunt, the preparation for the next hunt began—the whalers were chosen, and a high-ranking female was appointed to oversee their spiritual and physical preparation. Some years ago, the Makah stated their intention to rein-state this tradition, which caused public outcry and a debate over the value of tradition and aboriginals' role as protectors of the environ-ment and all of the world's creatures.

I was inspired to make a piece about this debate without taking sides but instead visu-ally challenging viewers to make their own judgments. I have explored many creatures in skeletal form, because this is the state we are reduced to before we transform into another being. Shamans also are often seen in a semi-skeletal form as they shed their skin to take another form. In this mask the skeletal form is also a reference to the great canoe journeys and hunts of the past as we look back on the feats of our ancestors.

Tradition in the strongest sense means to copy. To capture the true spirit of a piece requires innovation and creativity and the willingness to stretch across boundaries, thus starting new traditions leaving a lasting legacy.

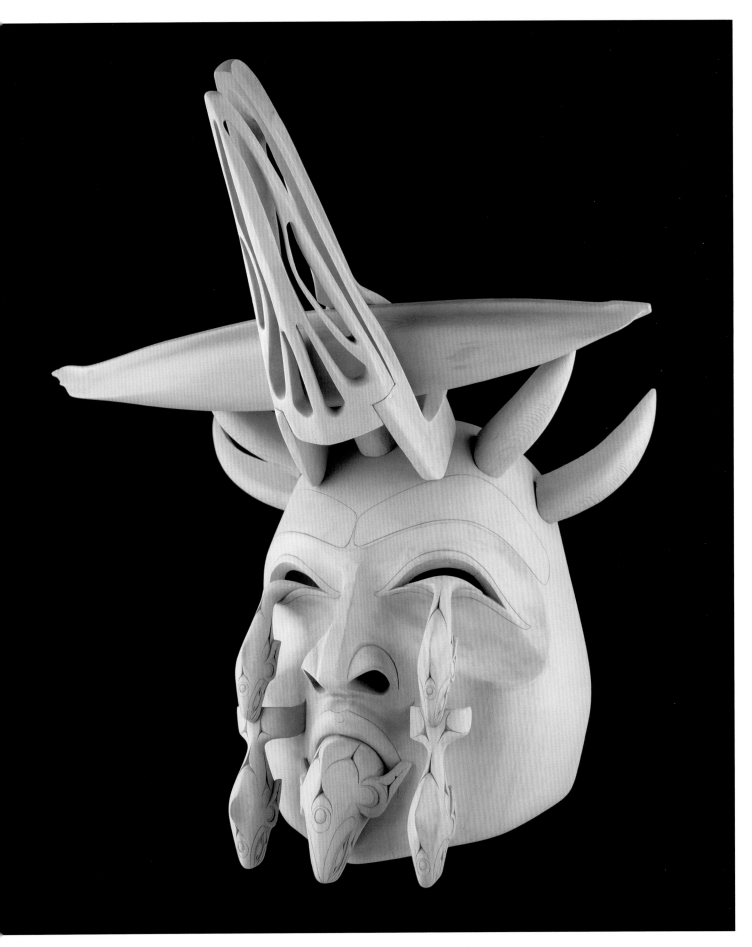

46 & 2 (Owl) Mask, 2010

COREY MORAES

Tsimshian
Red cedar, horsehair, feathers, beads,
yarn, bone, metal tacks, acrylic paint
26 × 16 × 10 inches (including train)

WHEN PURCHASING ARTWORK, the collector is essentially purchasing the artist's journey through life for the specific period of time it took to create said work. The artwork itself is the physical interpretation of what a true artist is trying to make you see: a moment in time. That is why my work tends to lean toward my current interests and my own personal experience up to this point in my life. I have a physical need to get that visual out of me, onto whatever medium I see fit for the purpose. 46 & 2 is a reference to a song by the alternative rock band Tool, but at its core is the analogy of where we are in relation to everything else.

Based on a Jungian theory. Owl is a helper of Shaman, often seen by others as a harbinger of death. A clearer understanding reveals otherwise.

Shaman sought to move to the next level of human evolution and consciousness.

It's believed that there are three levels of human evolution and each has its own form of consciousness:

FIRST LEVEL with 44 chromosomes. These are primitive peoples, like the ancient Aborigines in Australia who did not perceive anything outside of themselves. They saw only one large consciousness, without distinctions between organisms.

SECOND LEVEL with 46 chromosomes. That is us. We are a chaotic, disharmonic consciousness that is basically used as a stepping stone between the first and third levels.

THIRD LEVEL with 48 chromosomes (or 46 & 2, with 2 being the sex chromosomes, X & Y). This is the higher level of consciousness, our destination.

It is believed that you cannot reach this third level of evolution without first delving into yourself and basically cleansing your consciousness for the next jump.

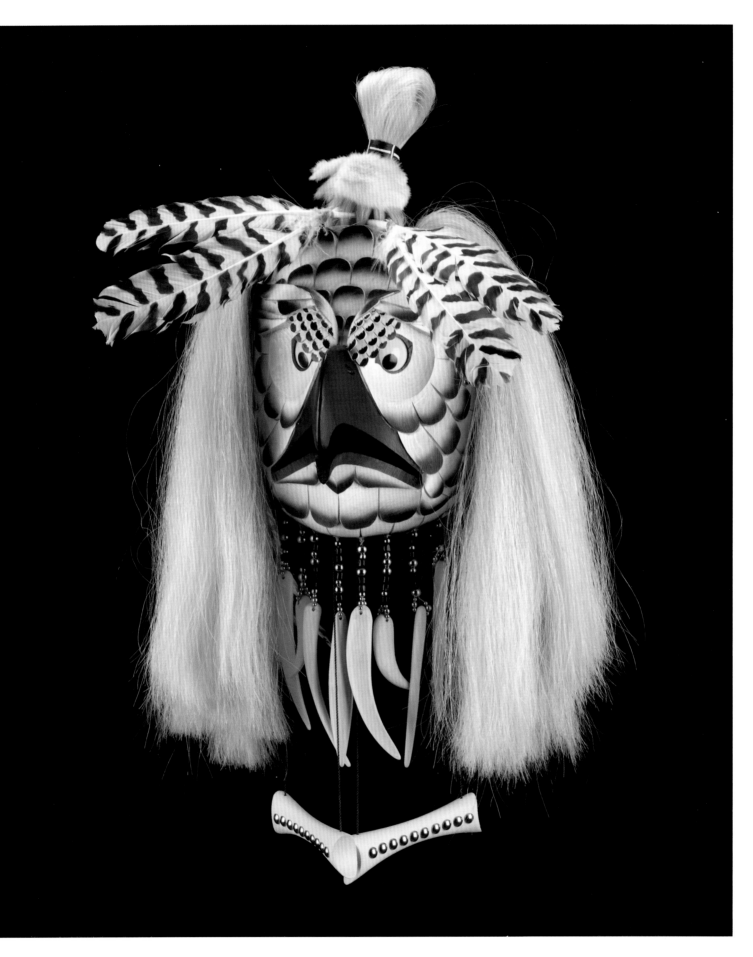

Me and My Two Dead Brothers Totem Pole, 2006

CHUCK HEIT

Gitxsan
Red cedar
58 × 24 × 16 inches

Me and My Two Dead Brothers
by Ya Ya, 2006–11

I WOKE UP to answer the telephone one morning. It was the saddest phone call of my life. I heard that my bro Mike had died. I am sad every time I think about it. I can't think about Mike without thinking about our bro Andy. Both of my brothers died with AIDS.

Our Kispiox village is a small place, and we all know each other. My parents grew up with Mike's parents. I did a lot of growing up with Mike. My kids are growing up with Mike's kids. Right here at the centre of our world. That's how the world spins the right way.

Andy is from nearby Gitsegukla village, but he grew up far away from here. I first met him in Vancouver. Years later he moved back home, to our Gitxsan homeland. He and his wife and new baby wanted to live with his granny in Kitwanga village, just down the big river a little ways from my Kispiox village. We got to see each other a lot. Then we both ended up working for our land claims for a while. When

he got a divorce, he came to stay with me for a few months. Soon enough he took a new wife. One sunny day they went up a mountain, and he went blind!!? They took a few days getting down from there. That's when he found out he had HIV/AIDS. His scary time started then. A time of denial. He refused all treatments.

After Mike died, I didn't want to go down to his parents' place. I knew it was going to be a very sad place. He was their fourth child to die. But that's where my heart took me. I couldn't let those people mourn without me. I love them and they love me, just as if I was one of their own. Always have and always will. My Fireweed Clan buried Andy and Mike in our Gitxsan fashion. We gathered ourselves together and took care of each other, and then we took care of our business. It is difficult losing someone who is close to you. That is why we Gitxsan gather ourselves together and help each other, especially in hard times.

One day I was looking at a red cedar log, and I started to get ideas. Ideas and memories were flowing through me. I did a quick little sketch, and soon enough I was chopping away at my new totem pole. A house post to tell a

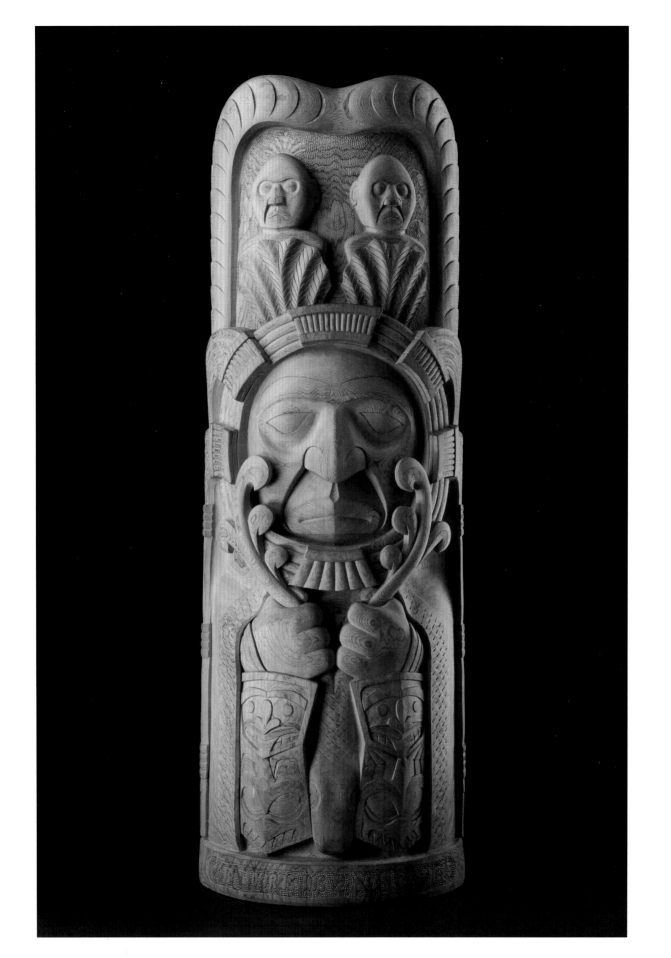

story. A very sad tale, so I thought at first. I didn't know that I had to tell the whole world. But that's what I started doing. Right away I was feeling better.

Andy and Mike and I were all members of the Gitxsan Fireweed Clan, and we were all proud of that. Both Andy and I were chiefs in our families. Little chiefs. All three of our families have long, long, ancient histories around here. Ancient privileges and ancient crests and ancient histories. I was thinking about all of that as I sketched. When I was satisfied with my sketch, I looked at it again. I started to see that the sketch was mostly about me and my feelings. I was starting to feel pride. I realized that I was still proud of my two dead brothers. Not just sad for them. Good old Native Pride.

I added in some more details on my family's crests, but I didn't want to show any crests from my brothers' families. Mike and Andy were dead, and they left us "naked." They didn't take anything with them when they left us. They were dead, and that's how I drew them. They were dead and could no longer see in this world; I put no eyes on them. Just some fireweed leaves for all three of us.

When we Gitxsan die, the father's side will call out our baby name. I had drawn my two brothers small, so we could remember them from their earliest breaths—when they could do no wrong, when they could make no mistakes; such innocence. That's when we look upon them with such love and envy and pride. When we have the greatest dreams for their futures. When we are the happiest for them, so happy to just have a peek at the little ones. When love and pride and happiness fill our eyes with tears. That's how I drew those two. I drew them with all my feelings.

All over the world people are losing friends and relatives to HIV/AIDS. I want the whole world to remember them, all of them, to look at them the same way. With love and pride. Not just with regrets. Both of my brothers died with AIDS, but they both died with lots of love, too. Giving and receiving love and happiness and pride.

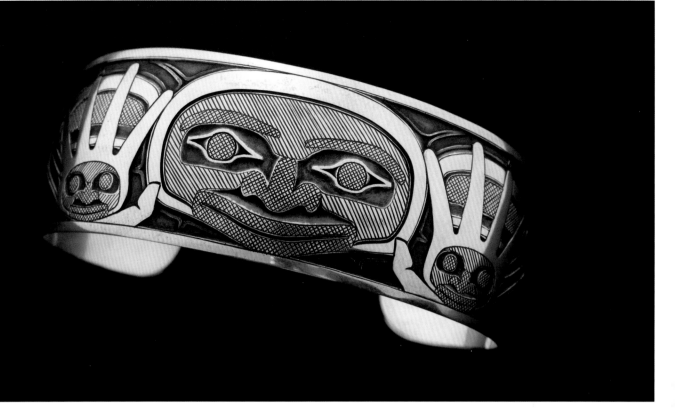

Moment of Insight Bracelet, 2009

RICHARD ADKINS

Haida
Silver
1 × 6 inches

THIS DESIGN IS about the moment someone has an epiphany, a moment of change or a rite of passage—you are not the same person after this moment passes. It is also about a moment of insecurity— what you are leaving behind is an immature version of yourself, which, in most cases, you have chosen to leave behind for very good reasons. The Raven is the voice inside the human trying to force the changes to take place. Wearing this bracelet is a reminder of the ongoing changes and cycles that occur in life.

Much as artists in the past understood how the bracelet would age over time, I started using oxidization to darken the metal in the negative spaces, separating them from the polished positive spaces. After a while I used cross-hatching in the positive spaces to imply tone or colour differences. In my work I am sensitive to what has come before me, and I am trying to add to the tradition by being a devoted artist creating original and meticulous designs.

Dogfish Mask, 2003

ROBERT DAVIDSON

Haida

Alder, operculum shell, cedar bark

17¼ × 10¾ × 6¾ inches

THE HAIDA HAVE two crests, or moieties, the Eagle and the Raven, with numerous sub-crests that describe the lineage of particular families. Each house, in the north, had a name, and my father was from the Shark house of the Raven Clan. The Haida, however, are a matrilineal society, and therefore my crest is Eagle.

I grew up in Masset, which is the most northerly point on Haida Gwaii, and the older totem poles from this region did not have the Shark on them. In Skidegate, to the south, it was more common. Over the years I have carved numerous Shark masks to honour my father and his family, and they are part of the regalia collection that I have created for use by my dance group, the Rainbow Creek Dancers. Shark is described in the Haida language as Dogfish Mother; in art, Shark is depicted stylistically with a single fin, and K'aad (Dogfish) has two fins.

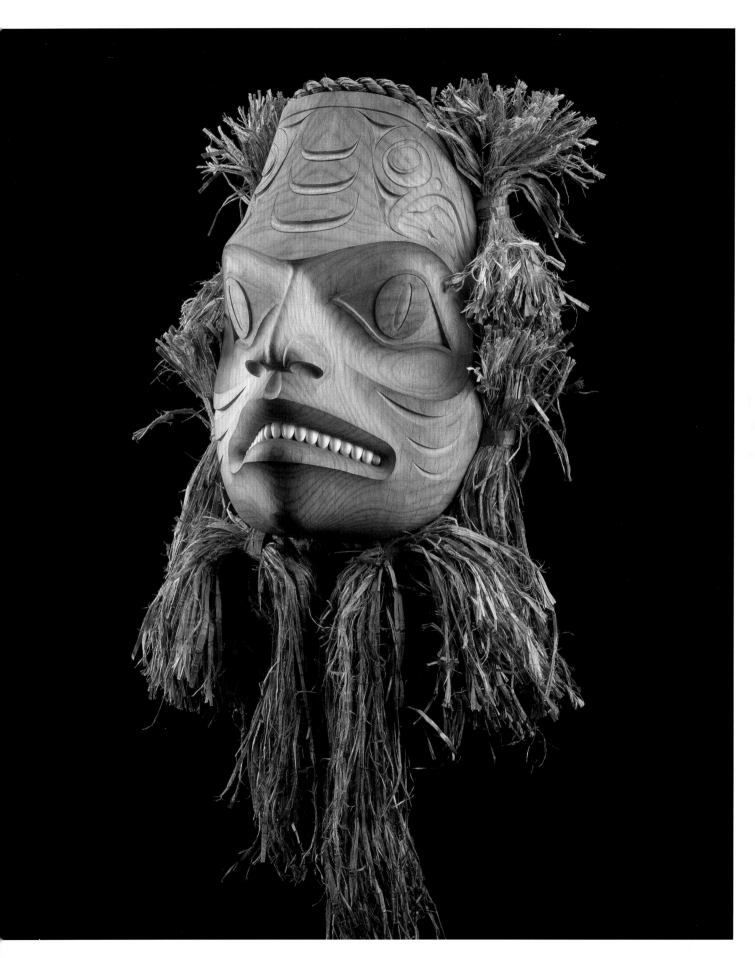

Berries on Sunshine Mountain Robe, 2009

LANI HOTCH

Tlingit

Thigh-spun merino wool, factory-spun merino
weft yarns, dye, felt, glass beads, sea otter fur
47 × 38 inches (plus a 10-inch fringe)

I HOLD MANY fond memories of picking berries both as a child and as an adult. Some years we have to work pretty hard, and sometimes it is pretty easy picking. One of our favourite places to pick in the Chilkat Valley is Sunshine Mountain, which is where I got the inspiration to weave this robe. The day I was picking, the fall colours were so vibrant, and the pungent smell of the cranberries mixed with the earthy scent of decaying leaves was intoxicating to the senses. I just wanted to capture that in this weaving.

The pattern at the top and bottom of the green and red border is called "Ancestors," and I chose it because picking berries is something Tlingits have done over countless generations. The pattern along the sides of the green and red border is called "Tree Reflections:" it represents the giant spruce, hemlock and cottonwood trees found in the upper Chilkat Valley.

The setting sun in the top panel represents Sunshine Mountain itself and the fall season when we begin losing daylight at a rapid pace. We had a pretty rainy summer the year I started this robe, and I wasn't emotionally ready for the dark of winter. The thought of weaving the sun helped me to get through the dark season. (Sometimes you have to make your own sunshine!) Peter Yarrow put it well in the lyrics to "Weave Me the Sunshine."

The second panel represents the highbush cranberry. The leaves of the cranberry turn a deep burgundy in the fall, and the berries themselves turn a brilliant translucent red. I love their vibrant colour, and I really wanted to present the cranberry as realistically as possible, so I chose to appliqué the leaves rather than weave them. I took some cranberry leaves and did some pencil rubbings to get the pattern of the veins, and then I used beads to sew the veins onto the felt. The felt leaves with just the beadwork were not realistic enough, so I embroidered them with yarn to give them the crinkly texture that the highbush cranberry leaves have. The clusters of glass beads represent the ripened cranberries, of course. I had the beads specially made by Haines artist John Svenson, and he incorporated some sand from Sunshine Mountain into the glass, thereby bringing the true essence of Sunshine Mountain into the weaving.

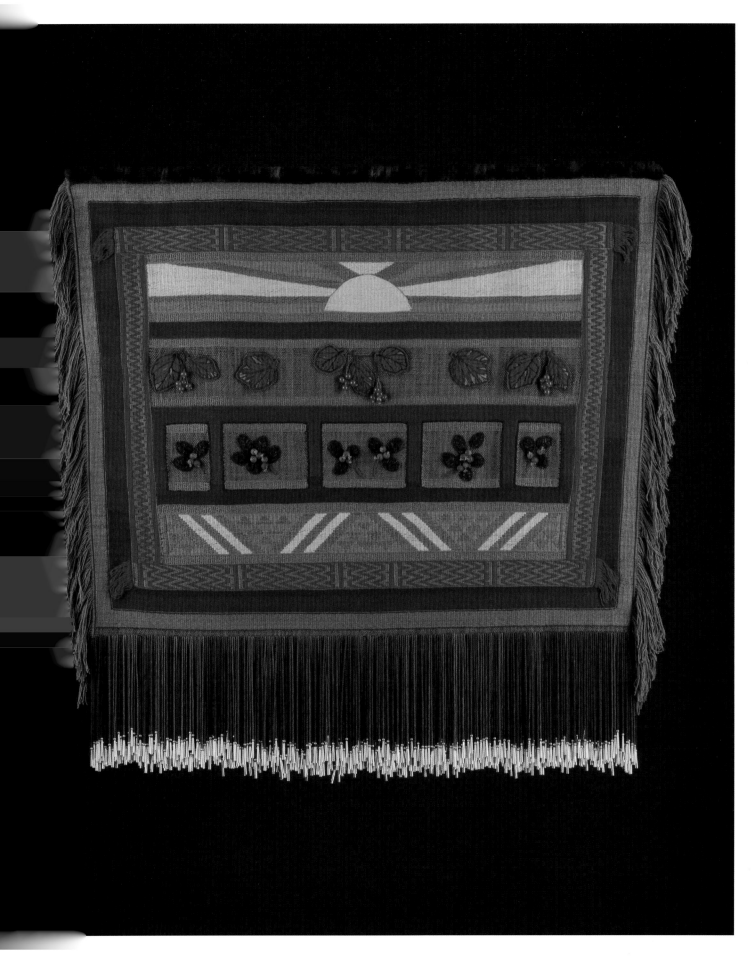

The third panel is the blueberries. The blueberry leaves are again done in felt appliqué and embellished with glass seed beads to show the veins in the leaves. I could not find the right colour of felt commercially, so I felted some wool myself. I also enlarged the leaves to better fill the allotted space in the weaving. John Svenson created the blueberries for me (again with Sunshine Mountain dirt), and this time I asked him to acid-wash them so that they would have more of the frosty appearance that the blueberries here have. The brown bars separating the blueberry patches represent the many fallen logs found in the blueberry patch. (It seems blueberries grow best in logged-over areas, and it is sometimes a struggle to keep your footing with all the fallen logs everywhere. It is a challenge, but the berries are well worth the effort.)

The fourth and final panel is an abstract representation of salmonberries and fireweed leaves, borrowed from the Tlingit spruce-root basketry tradition. The salmonberries are represented by the orange triangles within a triangle, and the fireweed by the slanting yellow bars. Salmonberries do not grow abundantly in the Chilkat Valley, but there are a few to be

found on Sunshine Mountain, and if you are lucky enough to find them, you generally eat them on the spot. The fireweed grows in abundance throughout the valley, and we have to walk through quite a bit of it to get to the berry patches. The salmonberries and fireweed leaves both come in a wide range of colours, but I chose the yellow and burnt orange to give some balance to the sun pattern in the top panel.

I used thigh-spun merino wool threads for the warp, and the weft yarns are factory spun. The *Berries on Sunshine Mountain Robe* is done in the rich colours of fall. The warp is dyed in variegated shades of moss green, and weft yarns are dyed a mossy green, golden yellow, burnt orange, brown, cranberry red and blue. The same yarn used for the wefts was also used to do some embroidery. The bottom fringes are tipped with gold-coloured cones and beads, and sea otter fur is used to trim the top of the robe. I had to use all that I know to weave this piece—Chilkat, Ravenstail and spruce-root basketry techniques were all employed, as well as embroidery, beadwork, felt appliqué and a newly acquired skill of felting.

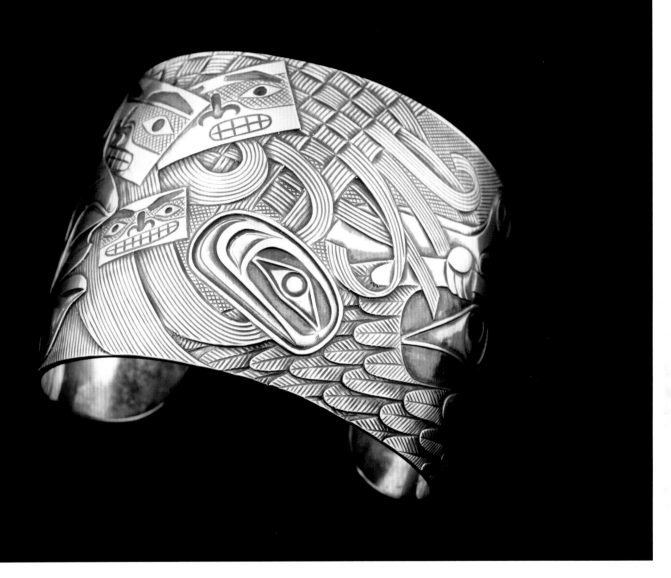

Daydreamer Bracelet, 2007

SHAWN HUNT

Heiltsuk
Silver
2 × 6½ inches

AT THE TIME I made the *Daydreamer*, it was my attempt to visually describe the creative process: a state in which my mind is completely open. It's as if there are no sides on my head... the ideas just float in. I can latch on to them and shape them. I remember when I was a kid I would do this at school. People said I was daydreaming... which is actually a pretty accurate description.

A Ma Ch—Spirit of the Sea, 2009

TIM PAUL

Hesquiat/Nuu-chah-nulth
Red cedar, glass, basalt, acrylic paint
9½ × 6¼ × 4¼ inches

THE PREPARATION TO go out to sea: we go straight off the beach and into the deep blue, the drop-off. The land, the homeland, becomes a jumble. This point defines our domain; it gives us markers to tell us that this territory is ours.

In modern times, these markers no longer help us to know where the fish are, and we need to move farther away. The landscape has changed so much. Small spirits ride on the waves and tell us that it will be a bountiful harvest. Now there is nothing to read. There were connections to salmon, to cod banks.

Spirits of the sea take you on the winds to the places where there is a good feeling.

I cannot say that in my lifetime, my children's lifetime, my grandchildren's lifetime that these resources will be there for them. My grandfather tells me about the predications and the quotas offered in the '30s that said we would never run out of resources, that there was abundance.

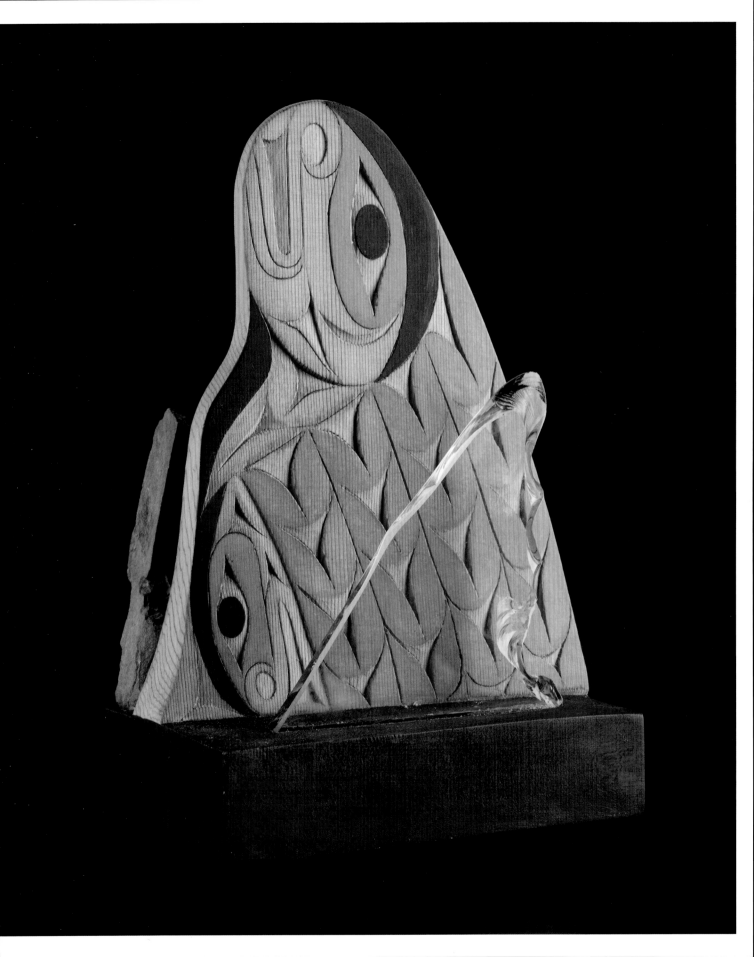

Blue Bear, 2006

KEN MOWATT

Gitxsan

Birch, cedar bark, abalone shell,
feathers, acrylic paint

12 × 8 × 9 inches

BLUE BEAR ENCAPSULATES the threats to bears' survival: the cars that speed along our highways, the uninformed people who feed bears and accustom them to human presence and the fast-moving trains that fail to stop when there is a need to.

We and the bears—the black and the grizzly and, occasionally, the kermode bear—live in this beautiful valley through which the Skeena River runs. The Native community of Kitwanga lies adjacent to the Kitwanga River, which empties into the Skeena. It is reached by road along Highway 37 North, which parallels the Kitwanga River, from the Yellowhead Highway, which runs alongside the Skeena. The Canadian National Railway bisects the community from east to west.

In the spring, the bears come down from the mountains to forage in the rich vegetation that grows along the riverbanks. All through the spring, summer and fall, until the salmon start to run, we share space and time with these beautiful animals. Then, as quietly as they came, the male bears, sows and cubs return to their winter dens. This has been their story every year since long before our time. Today, we can pretend that this cycle is still natural and idyllic, but it isn't so: humans have created obstacles.

Along the highway, I have seen a bear cub waiting for its dead mother—hit by a speeding car—to wake. Around town, I have heard of too many so-called nuisance bears, those raiding people's garbage cans and bird feeders and campsites, being put down only because they've become accustomed to humans. However, I think the worst of the killing occurs along the train tracks. On my way to the river, I have often walked along the railway and encountered a bear eating the grain that accumulates on the tracks, spilled from the freight cars crossing from the Prairies to Prince Rupert. These bears—and also moose—do not back down from defending their food when they are threatened, even by oncoming trains. Eagles need a long takeoff run to become airborne, and they too are often hit by fast-moving trains. As a result, each year thousands of animals are killed by locomotives.

This mask asks, Do we need to wait until bears and other animals are on the endangered species list before we act concerned?

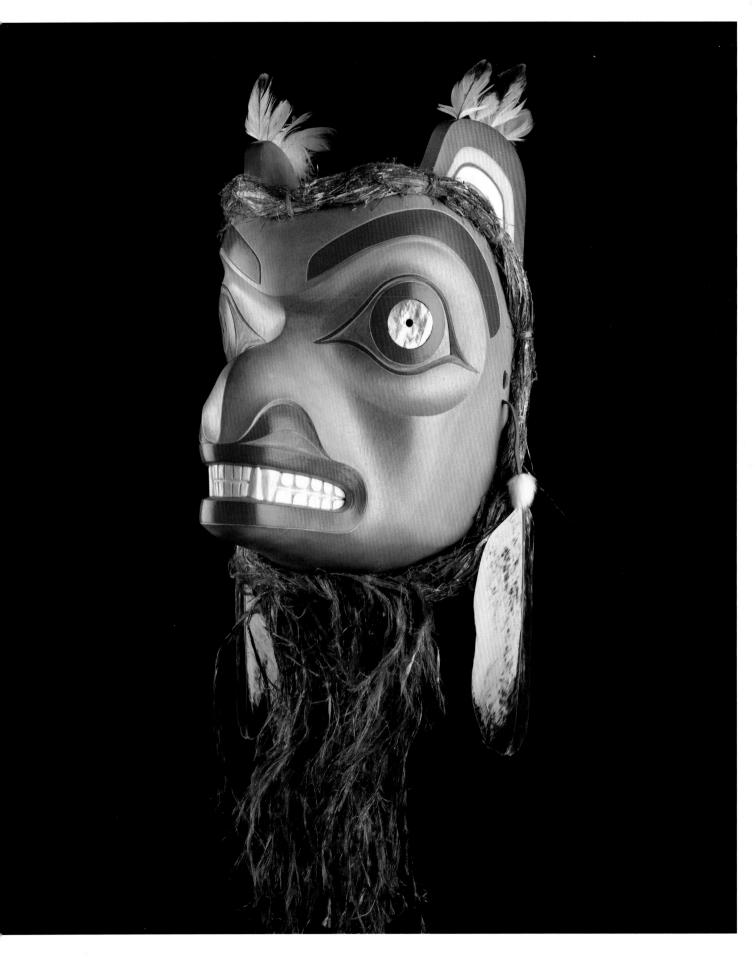

Saved by the Land Otters, 2011

PRESTON SINGLETARY

Tlingit

Blown and etched glass
21 × 17 × 6 inches

THIS DEPICTS AN oystercatcher rattle. The main goose-necked figure is Oystercatcher, revered for his ability to fly but also to dive into the water to catch fish. This navigation of realms, the water and the sky, demonstrates his special skills. The opposite end of the rattle is Mountain Goat, who can navigate the impossible terrain of the steep mountainsides. He also occupies the space close to the heavens.

The belly of the rattle has a hawk design. The human figure is in distress because he is resisting transformation into a land otter. Flanking the human are two land otters, which are luring him to their village where, if they are successful, they will transform him completely into a land otter.

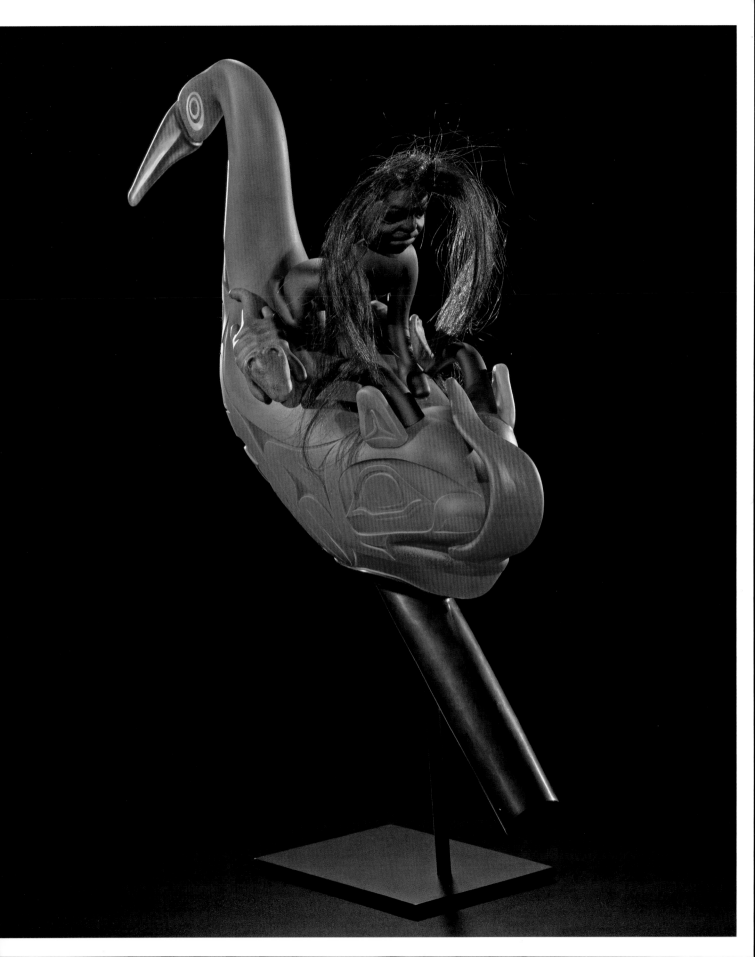

A Gift for Qulqulil Comb, 2003

SUSAN POINT

Coast Salish
Red cedar, copper, paint
82 × 31 × 4 inches

THIS IS THE STORY of Qulqulil. She was a woman of unusually large size, a freak of nature, who was shunned by the villagers and ultimately cast out by them. As is often the case in human affairs, the ordinary could not suffer the extraordinary. So Qulqulil, who had no relatives, was condemned to live the life of a hermit, deep in the forest far away from human contact. Nobody knows where. Her only friends were the birds and animals of the forest.

Qulqulil would roam along the beach to escape the gloom of the forest, to behold the glory of the ocean and to commune with the spirit of the wind. Walking along the beach one day, her large body awkwardly plodding through the coarse sand, she came across some village children who had been swimming but were now basking their bodies in the brilliant sunlight. One of the older boys sat on a rock by the water and was shaving with a clamshell. Qulqulil, out of sight, watched them for some time. As she stood silently observing the children, an intense longing for human company welled up in her heart. She moved closer with the caution and intensity of a predatory animal. Suddenly, like a bolt of lightning from a clear sky, she swooped down upon her unsuspecting victims. This fearful apparition paralyzed the children—and before they knew what happened, Qulqulil had caught them and put them in a large snake basket, which she carried on her back.

Quickly leaving the beach, she sought the cover of the dense forest to start the long way home. As she walked along the trail, the older boy who had been shaving with the clamshell began to cut a hole in the bottom of the basket. He finally had a hole big enough to allow some of the children to escape. As they did, they could

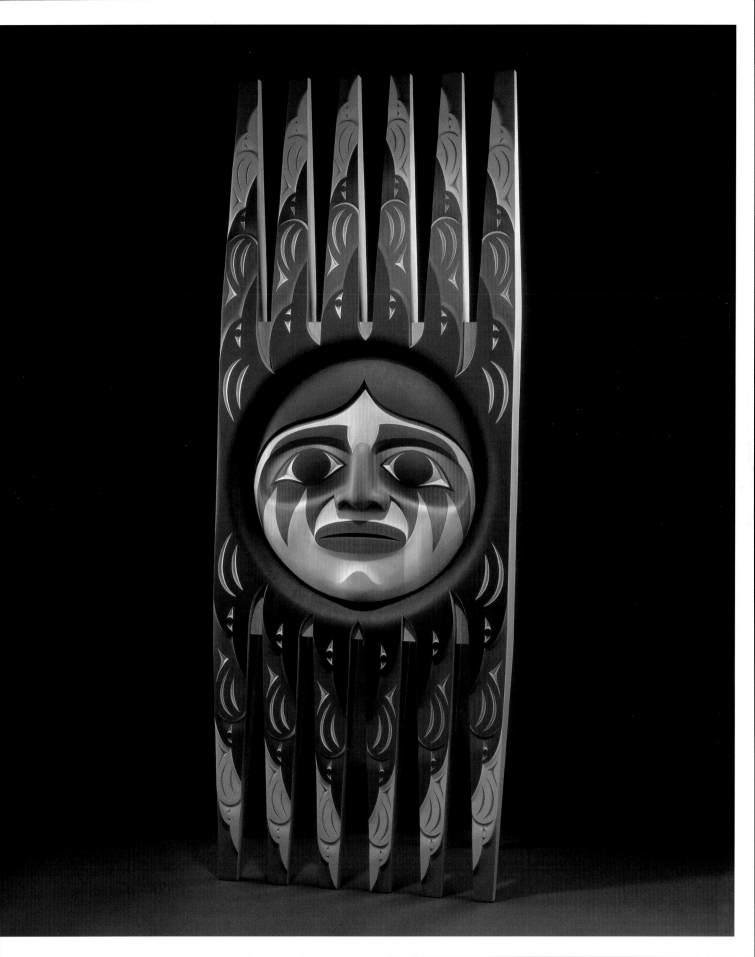

not help but make some noise, and Qulqulil, whose senses were acute from the solitude, stopped. Taking the basket from her shoulders, she opened the lid to make sure the children were still there. As the lid of the basket opened and Qulqulil's large face appeared, she brought terror into the hearts of the children. But, as the remaining children covered the hole in the basket with their bodies, Qulqulil thought that all was in order, closed the lid and continued on the journey home.

On arriving home, Qulqulil did not want her young captives to escape, so she immediately proceeded to smear pitch from the wild cherry tree over the eyes of the children. By robbing them of their sight, she hoped to discourage any attempt by the children to make a run for it. However, the youngest girl pressed her eyes so tightly together that when Qulqulil applied the pitch, her eyes were not completely sealed, and she was able to see.

Several days later, at that time past twilight when the night has firmly drawn the earth to its bosom, Qulqulil and the children sat around the fire. But for the sharp crackling of the fire, the forest was completely silent, and the stars stood prominently overhead. The silence was broken only when one of the young children asked Qulqulil to dance around the fire. The other children joined in, they all urged her to dance. Qulqulil rose and began to dance in a cumbersome, rhythmic motion around the fire, her large body casting a ghostly shadow on the surrounding forest. Suddenly, without warning, the children rose and pushed her into the fire and made their escape. Falling into the fire, Qulqulil screamed, "Please help me, my young brothers and sisters, I was only trying to help you." She desperately struggled to get away from the fire, but her hair had been set alight, and as the flames consumed her long black hair, the lice jumped from her scalp and were miraculously transformed into tiny birds that flew into the gloom of the night—a wondrous sight to behold.

Qulqulil survived and managed to keep two of the boys captive. One day she told the boys to accompany her on a duck hunt. The boys, determined to escape, quickly devised a clever scheme. Before leaving on the hunt, they placed extra bush mats on the seat of the canoe where Qulqulil would sit, thus raising the centre of gravity and making the canoe unstable. As they reached the hunting grounds at Point Grey, Qulqulil, by a stroke of luck, dozed off. The boys began to rock the boat with all their might, and, although the violent motion roused Qulqulil from her sleep, in her bewilderment she was not able to steady the canoe—and with a piercing scream she fell overboard.

Qulqulil could not swim. With her arms flailing in a pathetic attempt to stay afloat, in her panic she cried out, "Please have pity on me, please have pity on me!" But the lure of freedom stifled any pity the boys might have felt, and grabbing the paddles the boys turned the canoe in the direction of the shore. Yet in a curious way, perhaps because their consciences were unsettled by their violent act, the boys shouted: "We are trying—but the strength of the current will not allow us to get to where you are and save you." But they had no intention of returning, and left Qulqulil to die.

It is said that the reason the waters at Point Grey are so rough is because the spirit of Qulqulil still restlessly roams the waters in which she was drowned.

Malachan Warrior's Mask, 2001

WILLIAM KUHNLEY JR.

Nuu-chah-nulth/Ditidaht

Red cedar, acrylic paint

17 × 19 × 11 inches

MALACHAN IS A region now defined as Ditidaht or Nitinaht Reserve, also known as Balaats'adt, a large territory within the Nuu-chah-nulth nation that encompasses Cowichan and Nitinat Lakes in the southern region of what is now Vancouver Island. It is a region rich in resources with a long ocean border that offers salmon and sea life and a forest of berries, deer and other wildlife.

I am from the Nitinaht Reserve #11, on the east and upper side of Nitinat Lake near the mouth of the Caycuse River. A long time ago, this was a summer village site used only during fishing season. The Ditidaht fished at night for dog salmon and hunted ducks near Balaats'adt using light from pitch torches.

This mask was inspired by master carver and artist Chele'tus, and it was my first serious exploration of Nuu-chah-nulth formline. I have painted a wolf design on the warrior's forehead, symbolizing an important practice known as Tluqwaana.

The Malachan Warrior is the protector of the land, sea and surroundings that involve daily life.

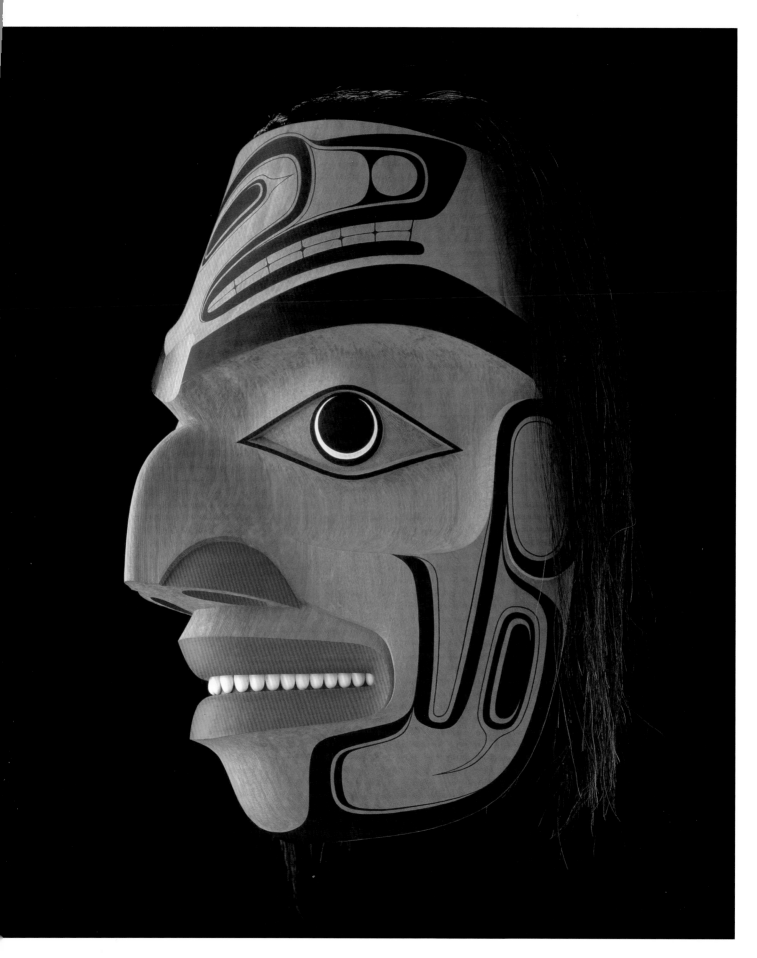

Frog and Wealth Woman, 2005

KEITH WOLF SMARCH

Tagish/Tlingit
Birch, gold leaf
9 × 5¾ × 3 inches

I AM A Tagish/Tlingit and a descendant of, and of the same clan as, Skookum Jim, who discovered gold and set off the Klondike gold rush in 1897 in Alaska and the Yukon. He was travelling with Tagish Charlie, who became known as Dawson Charlie after the gold rush, and his sister Kate, who would later marry the famous miner George Carmack. They were moving through the network of creeks and rivers by foot and carrying lots of gear when, one night, Skookum Jim had a dream about Wealth Woman.

The best-known story of Wealth Woman tells of hunters in the forest who could hear her child crying. They would focus on the sound and try to chase it, shedding their packs and clothes and following the voice before it became too faint. If she came into view they would try to touch her, knowing that she would grant them great wealth.

Skookum Jim awoke excited by her presence in his dream and continued on his quest for gold. They were walking a creek edge when they saw a deep hole with a frog in it, struggling to get out. They continued on their way, but after travelling several miles the fate of the frog continued to haunt Skookum, and he dropped his pack and ran back to rescue the frog. Frogs to our people are spiritual and second only to the land otter, so his respect for this creature is easy to understand. Soon after, they came to what is now known as Bonanza Creek, and the rest is history—they found gold!

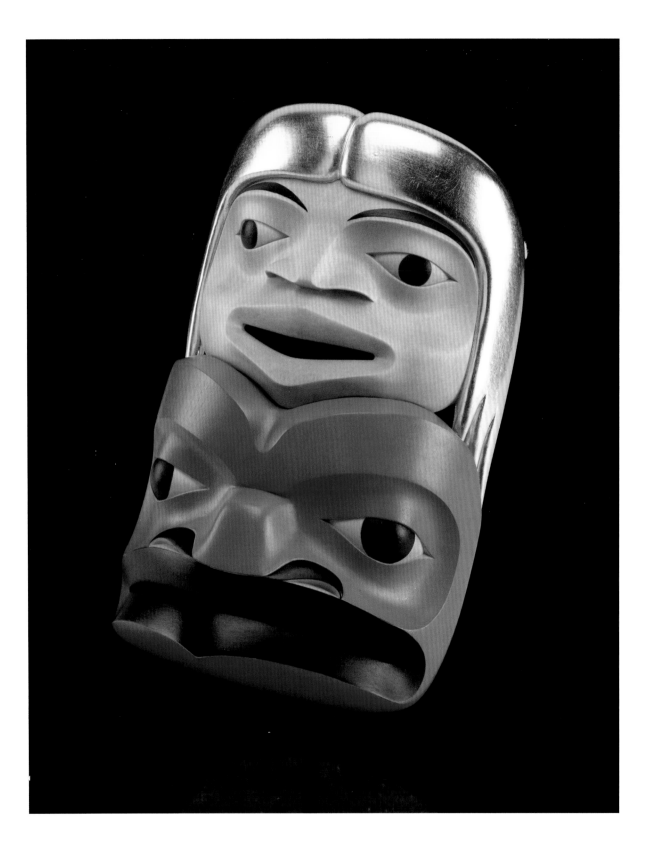

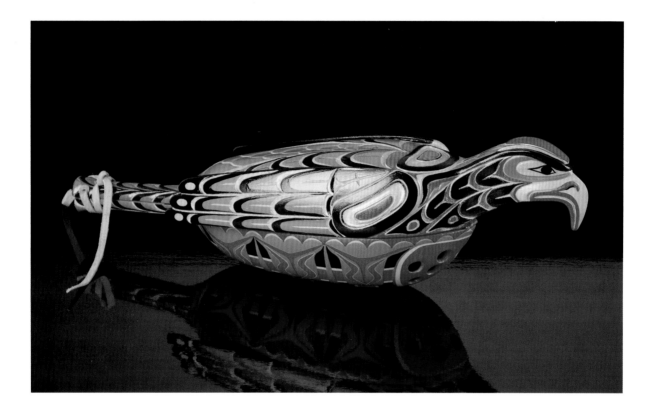

Fire Thunder Mask, 2007
and Rattle, 2011

GLENN TALLIO

Nuxalk
Mask: Red cedar, yellow cedar, paint;
17 × 16¼ × 12 inches
Rattle: Red cedar, leather; 23 × 7 × 7 inches

IN NUXALK MYTHOLOGY, Thunder is the most powerful patron among the supernatural dancers and a senior member of the Kusiut. The Kusiut is one of the two main ceremonial societies, and the dance of Thunder's human protégé is considered one of the most important rituals. Traditionally the society's gatherings began in November and continued through to March.

The rattle is constructed in chambers and lined with copper to protect the wood. The large chamber was filled with embers that would fly out as sparks when the rattle was shaken by the dancer. There were four thunderbirds carved with many variations.

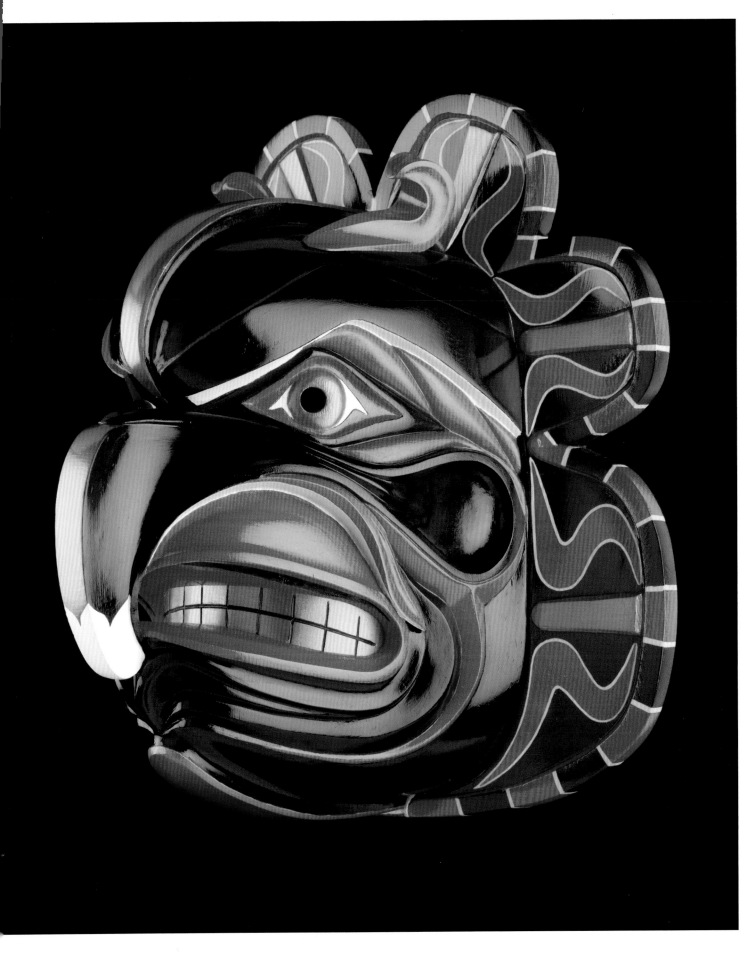

Tangwaan 'Laanaa Xuudaa
(Chief of the Sea Box), 1999

CHRISTIAN WHITE

Haida

Argillite, catlinite, mastodon ivory, abalone

9¾ × 10¼ × 7 inches

THE CHIEF OF THE SEA was the highest deity of the Haida ocean spirits. Haida Gwaii is surrounded by powerful, turbulent ocean currents. This box honours all the ocean spirits, and all the figures are Haida family crests.

Sea Grizzly on the front of the box is one of the Chief of the Sea's many forms. On each end of the box are the killer whales known as Skaana, which is the same word as "super-natural" in the Haida language—these are the ocean people. They are the male spirits that dwell under the capes and headlands of Haida Gwaii. The back of the box is the supernatural shark, referring to the rare occurrence of shark sightings, such as great whites and basking sharks, around Haida Gwaii. The feet of the box are the servants of the chief—Sculpin and Halibut. The top surface is engraved with killer whale and sea lion designs. The octopus sitting on top of the box is the shaman's connection to the ocean world.

The Haida shamans would fast and cleanse themselves and drink salt water to reach the state of mind between life and death necessary to travel to other dimensions. Often they would return with the stories of the ocean people that are told with chants and instruments used by the secret societies. Just as often, they wouldn't return, and their skulls are depicted in the arms of the octopus. Shamans often lived outside the village and interacted with villagers only when called upon by the chief. When the Haida travelled by canoe to hunt or to visit other villages, they would pass by the headlands where the ocean people dwelled and make offerings of tobacco, eagle down and eulachon grease.

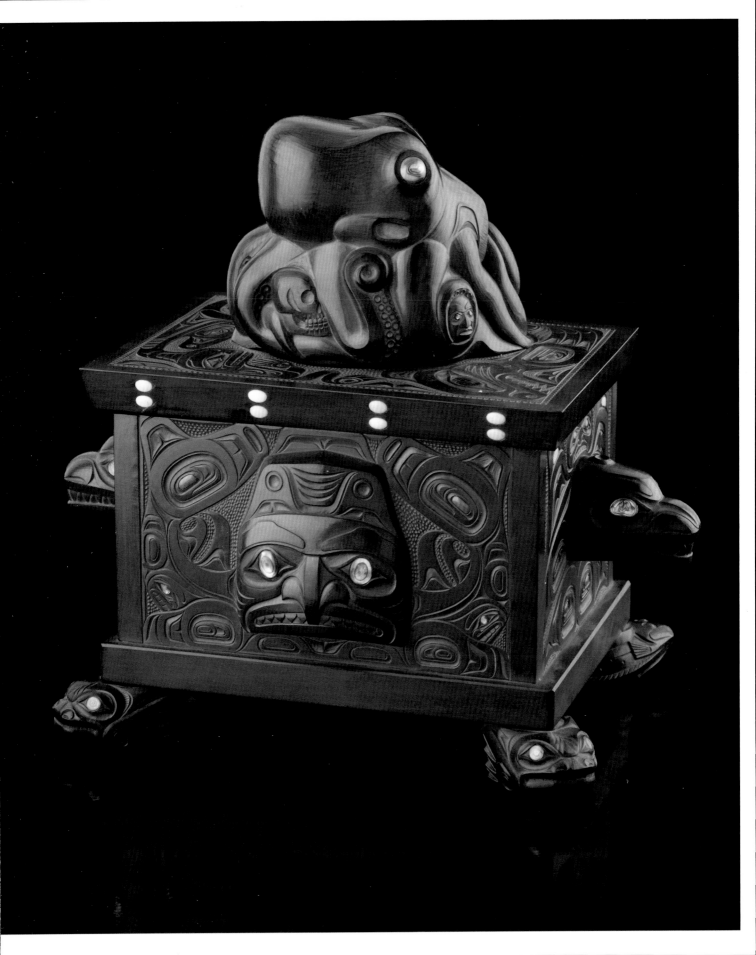

Wee-git's Many Tongues, 2009

LYLE WILSON

Haisla
Red cedar, paint
39 × 39 × 17 inches

PACIFIC NORTHWEST COAST masks have been rightfully included in the overall body of today's art world. However, a few purists want the mask's role to remain a traditional one, so that it is stored away and out of sight after each ceremony. When I first started carving, this issue wasn't important to me because of my eagerness to carve. A few years later I stopped to consider the argument and came to agree with the traditionalist camp and basically stopped carving masks for sale. Yet there was a part of me that chafed under this self-imposed restriction.

A couple of years ago I carved some masks and made them available for a newly resurgent Haisla dance group at Kitamaat. This decision led me to rethink my stance on the mask issue. Since my goal is to do the best I can each and every time I use a paintbrush, engraving tool or carving knife, the separation of masks for traditional usage only seems impractical. During the actual artistic euphoria, the only issue that's important is whether I'm doing my work well. If my completed work enters the domain of a

Native person using it in its traditional role, it is a bonus. A non-Native using it in a manner that respects and highlights its artistic qualities also makes me feel good. I am aware of the need to cultivate the arts in the Native community, and like most artists I support their growth. Perhaps it's the aging process, and I've lost patience with the argument and only look toward filling my remaining years with carving what I want to, but I feel positive about my simplified artistic direction. So, in a small way, *Wee-git's Many Tongues* is my "re-entry" into the world of making masks a larger part of my carving creations.

The subject of this carving is one of my favourites: Wee-git, the mythical Raven Trickster! The background story concerns an episode where he used his magic powers to steal the ball of light and release it into the heavens. Wee-git occupies the centre surrounded by the sun's corona of light rays, which double as a series of sharp, arrow-pointed tongues that refer to his well-known habit of telling tall tales.

Wee-git's Many Tongues is not really a mask because its size precludes it from being worn over the face. A traditional Haisla Big House

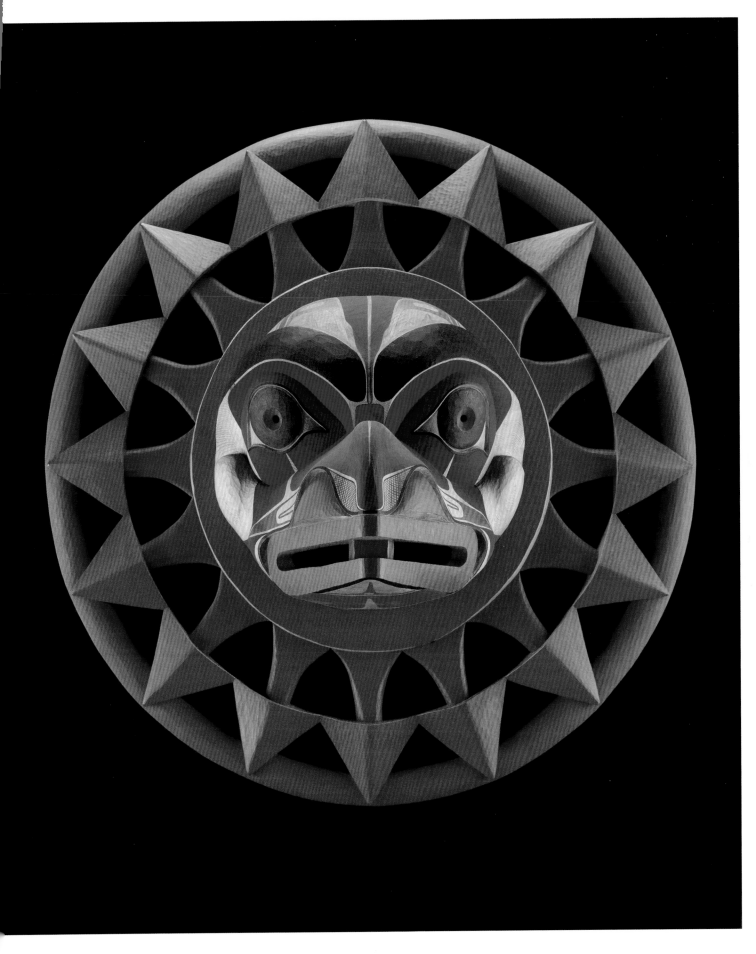

often featured a single monumental carving fastened to the outdoor roof gables. Such carvings displayed the owner's clan or crests. *Wee-git's Many Tongues* is the right size for such an honour, but since the Haisla version of the Big House no longer exists, that traditional role is denied to it. Instead, it is meant for a wall in a contemporary house and conceptually acknowledges the fact that we, Haisla, also live in modern houses that we fill with things that are of interest to us. So, I've called this piece a mask-sculpture: something that incorporates the traditions of masks, Big House sculptures and the modern home's wall.

In ancient times, masks were seen in motion as well as in darkness, illuminated by the flickering light of a bonfire. Large clan sculptures were mounted on roof gables and seen from below and at a distance. In both cases, the carvings were very hard to view clearly. Not only do contemporary carvers enjoy a wider range and better quality of tools, but also the carvings they produce are affected by the changed circumstances of modern society. The end result is a precisely executed carving that invites the viewer to examine it.

Although I openly acknowledge the importance of keeping Wee-git's place in a traditional story, I've also tried to shift the focus of *Wee-git's Many Tongues* toward an audience already well versed in the story. This allows the carving to function in a manner that respects ancient traditions while allowing a new element the same respect. This mask-sculpture reverses the movement element of the viewing experience: the "mask" doesn't move but the viewer must, in order to see the full sculptural effects of the central face and how the surrounding corona's rays/tongues are pierced through to the point of sculptural separation.

Wee-git, it seems, has some new tricks to show us.

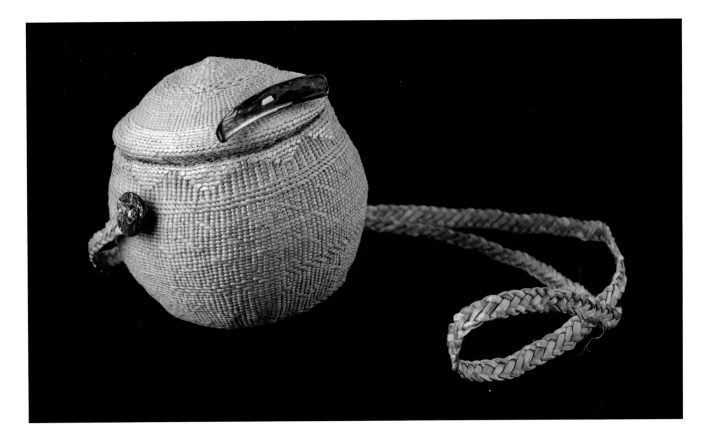

Spring Emerging
Purse Bag, 2008

ISABEL RORICK

Haida
Spruce root, yellow cedar, wheat
grass, twisted nettle fibre, abalone
5 × 5 × 5 inches

THE INSPIRATION FOR this piece was to make a new object using traditional materials and techniques for the *Woven and Sewn in Time* exhibition at the Spirit Wrestler Gallery in 2009. I started to weave around a gourd, but I bound it too tightly and the gourd cracked. I abandoned the gourd and went with a heavier root, weaving it really tightly to make it solid. The signature is inside the purse. The lid is all free-form weaving. The hinge is made from nettle fibre.

The pattern is called Spring Emerging—the plants start small at the base and expand with leaves as the design wraps around the side of the bag. A quarter of the way up the basket are three rows representing the earth, with the plant roots underneath. The jagged lines are the spring rains nurturing the plants. Close to the top are another three bands representing the sky, and the triangles above are the sunrays pointing to the earth. The strap is woven in yellow cedar.

Housepost, 2006

SUSAN POINT

Coast Salish
Red cedar, etched glass
107½ × 35 × 11 inches (wood side),
11 feet × 35 × 11 inches (glass and wood side)

THE FORMAT OF the house post uses two separate pieces of wood (Western red cedar), each one being a half-cylinder shape.

The artwork draws on the many legends about Xe-ls, a supernatural being with powers of transformation. He could take on different animal forms at will, often changing into a bird on his journeys through the world. Xe-ls had a mischievous character, and although he took the role of protector in many of the legends, he also enjoyed teaching lessons to the humans and animals he encountered. There are stories of him transforming a would-be assassin into a crane, and teaching Raven that all beings must experience mortality. The stories of Xe-ls are a vibrant part of the oral tradition that I celebrate through my artwork.

The imagery in this house post creates an artwork that is eleven feet tall and features eleven bird images, with the bird forms almost woven in and out of each other. On the one side, the centre of four bird bodies incorporate four human faces, representing different generations—a mother, father, son and daughter. The form of the bird at the top of the house post is created in glass (bringing the total height to eleven feet). On the opposite side is the face of Xe-ls with four bird forms carved around him—the fifth bird is carved on his forehead.

This image represents the metaphysical journey through life, the continuance of human life itself and the links from one plane of reality to another. The fluid rhythm of the overall design is suggestive of a river, touching on the theme of the river of life—water being an important element that links all human and animal life to the earth we inhabit.

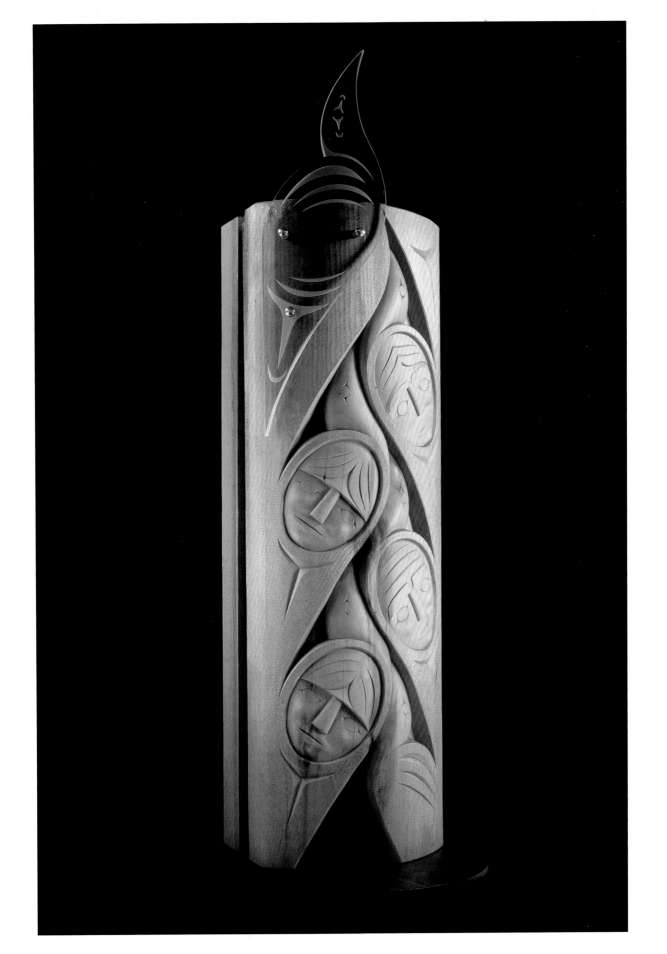

The Man Who Fell
from the Sky Bracelet, 2010

LUKE MARSTON

Coast Salish

Chased, repoussé and engraved silver,
abalone shell

1½ × 7⅓ inches

THIS IS THE first bracelet I made after returning from Italy, where I took a workshop on repoussé and chasing with master silversmith Valentin Yotkov. Its design is a new take on the old goat-horn bracelets that were collected at the time of first contact with Europeans. I really like the form of the goat-horn bracelets and adapted it to silver and gold. The bracelet tells a legend that I am still researching to find out the story of each person.

At the beginning of time, before there were any people on this earth, the heavens opened and the first man fell to the ground. He fell as a bird and transformed to a human when he landed on Mount Prevost in Cowichan Valley. He had a dog with one horn in the centre of its head; he also carried a red staff, and his name was Syalutsa. The Creator told him to walk the land and bathe in all the rivers, lakes, streams and creeks and use cedar boughs to cleanse his body.

The second man who fell to the ground was Stutsun. He also fell onto Mount Prevost, and when he landed Syalutsa told him about bathing in the rivers and lakes and streams. Stutsun did the same as his brother and walked the land and bathed. He had tattoos all over his body, and when he made his home at Halalt he painted his house in the same design as his tattoos.

The next to fall was Hwuneem', then Swutumtun. Suhiltun landed next with all the dance regalia for the black-and-red-face dancers. Next were Thulpul'thw, Swutthtus, Kwukwmut-siin, Sultimul'thw, Hunimul'thw and Ski'lum, and the last was Swutun, who fell and caused an earthquake in Stz'uminus Bay.

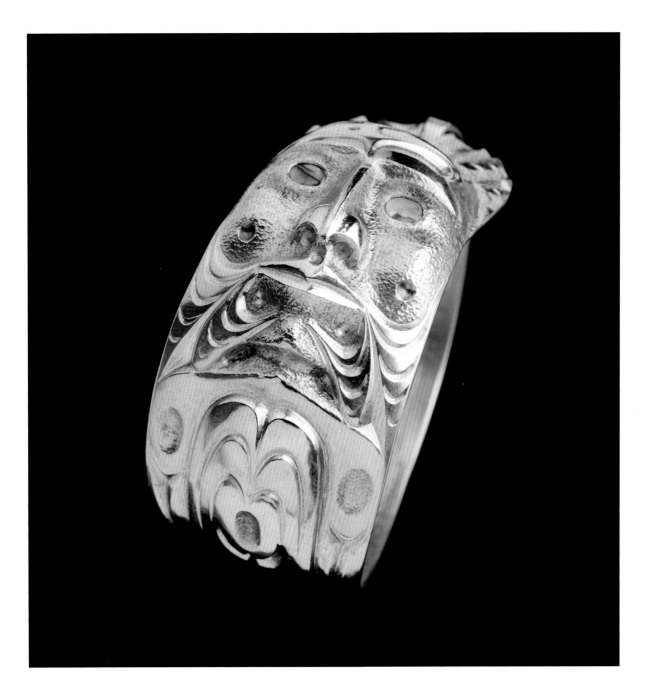

Gagiid Mask, 2002

ROBERT DAVIDSON

Haida

Red cedar, bear fur, horsehair, acrylic paint

14 × 10 × 7 inches

GAGIID IS A character I began to explore for use with the Rainbow Creek Dancers. When I showed my first version to my grandmother Florence Davidson, she commented that she didn't know Gagiid could be so handsome.

For the Haida the ocean is a realm of great spiritual presence inhabited by magnificent creatures we know, as well as by supernatural creatures that are greater in scale, beauty and design than can be imagined. Gagiid is a crazed and wild character, somewhere between human and supernatural, who has been lost at sea. After his canoe capsizes, he survives in the cold ocean water until finally he swims to shore and lives out his life in the forest. Long periods alone in a canoe will allow spiritual forces to take over a body, and when someone capsizes at sea and then manages to fight their way to shore, there is a strong possibility that these forces will take control of that person too.

When Gagiid comes ashore, he is crazed and wanders the beach adapting to his new form. He grows hair over his entire body and, as he is ravenous with hunger, grabs sea life on the shore and in the shallows, including whole sea urchins that drive spikes through his face. Over time his powers increase, and he learns to fly. As he becomes more bold and willing to interact with his former world, he seeks out human villages, often flying over the heads of hunters returning late to the village. My tsinii (grand-father) explained to me that Gagiid is a person whose spirit is too strong to die.

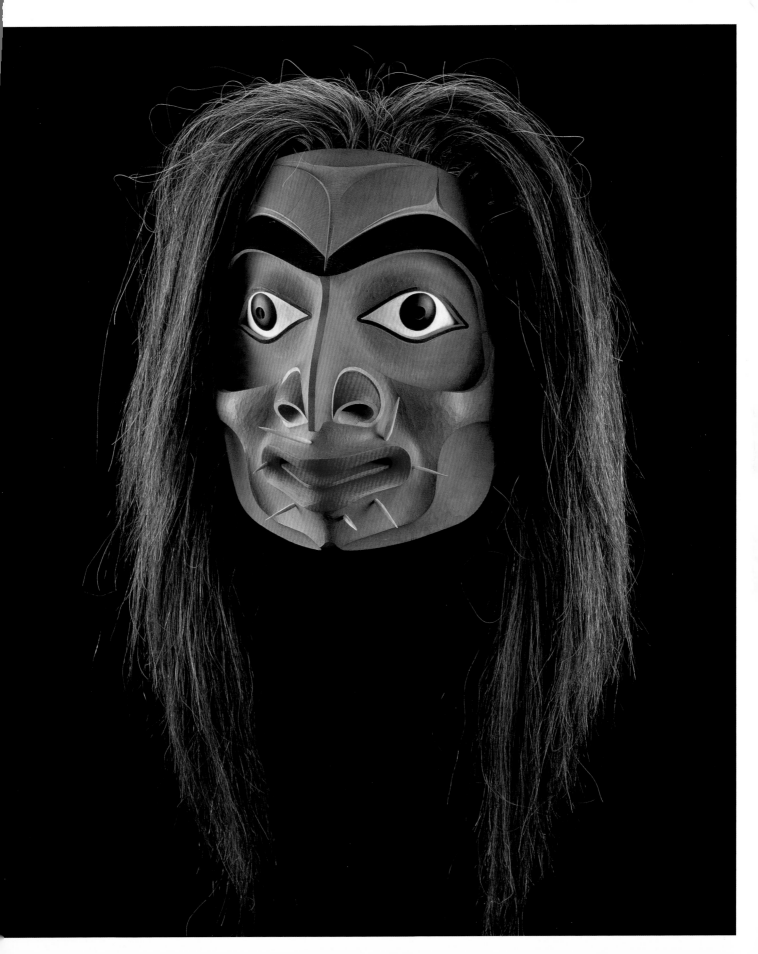

Ma ii-pu-tu (How We Revere the Family), 2010

TIM PAUL

Hesquiat/Nuu-chah-nulth
Red cedar, metal rod, acrylic paint
16½ × 12¾ × 4½ inches

THIS SCULPTURE IS all about revering the family and incorporates three motifs: Wolf, Raven and Ancestor.

Qwa-ya (Wolf) represents the family structure, from the oldest to the youngest. The strongest and the oldest is the leader. Everyone else has a role and responsibility within the family. The family symbolizes real care and love, with the wolf as our teacher.

Qu-uu (Raven) is the glutton, wanting everything from beautiful females to all the good things and pleasures of life—even though they might not belong to him.

A-u-mit (Ancestor) represents all the ancestors that have gone before us. Our ancestors witnessed the power of nature on our lands, the devastating winds, fires and floods. We have learned from nature; nature is our teacher, and our ancestors pass this knowledge on to us.

Being related to nature has taught us that we come as one from nature. Having witnessed all the cataclysms of years gone by, we have yet to learn to take only what nature gives us. Our ancestors tell us that we have relatives that live inside the mountains that we call "earthquake foot"—they are always happy, but when they dance, they shake the earth and remind us that we are small and fragile. We are not at the top of the heap in terms of the world, and we are really only a small part. Ancient knowledge teaches us to respect ourselves and to respect others, and this applies also to nature.

We must realign our thinking to listen to people who know the world from the top of the mountain to the bottom of the sea, the lakes and the rivers, and the creatures within. If we start to disregard these relationships, they will lead to quick lessons from nature that will tell us these losses are forever. Wolf and Raven and Ancestor are part of stories that tell us of historical fires and great loss, so that we know these events have happened and affected our landscape—and could happen again.

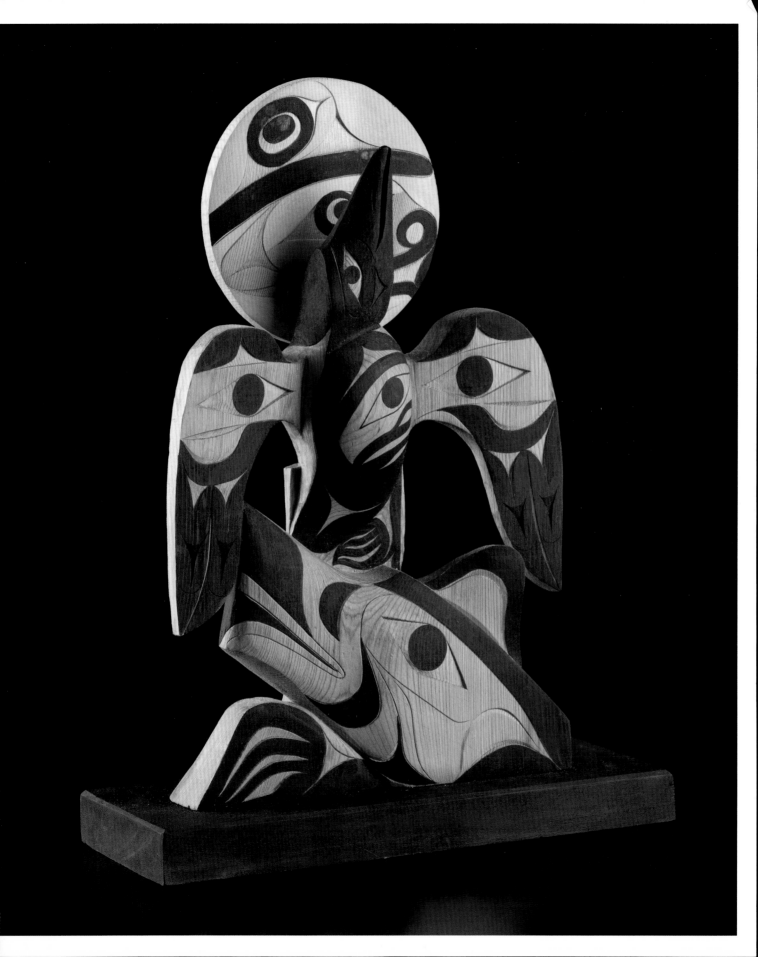

'Namgis Headdress, 2008

TOM HUNT

Kwakwaka'wakw
Red cedar, copper, horsehair,
cedar bark, crystal, paint
22 × 38 × 16 inches

WALAWIDI "One from Whom Things Are Wished From" Tom Hunt Jr. is the son of Kwagu'l Fort Rupert hereditary chief 'Namugwis George Hunt Sr. and matriarch Mukuxwi'lakw Mary, née Henderson, from the Ligwilda'xw Campbell River Nation. Tom comes from a long line of chiefs and carvers. The Hunts and the Hendersons are two prominent families among the Kwakwaka'wakw that have continued to practise their family traditions, ensuring their family legacies through their artwork, potlatching and feasting.

The 'Namxiyalegiyu (Halibut-Like Sea Monster) mask was commissioned from Tom by 'Namgis Nimpkish Valley Nation chief Waxawidi "Canoes Come to Him" William Wasden Jr. The mask was created for ceremonial use and danced at William's potlatch in Alert Bay in 2004. The Sea Monster mask is used in both the Tseka (Sacred Winter Ceremonies) and Dluwalaxa (Returned from Heaven Ceremonies).

DURING THE MYTH time, supernatural beings and mystical creatures occupied the world. The mythological raven, U'mel, was the chief over all the ancients. Among the myth creatures was 'Namxiyalegiyu, a gigantic sea monster with the body of a halibut, the dorsal fin of a killer whale, a wide mouth with numerous teeth, a large head crowned with spiral horns indicating its supernatural quality and, at the centre of its forehead, a quartz crystal that was the source of unequalled spiritual power.

Strict laws were given by Iki Gigame', the Creator, Great Chief Above, to govern the world. In time, some of the myth creatures chose to shed their supernatural costumes to become people and were the first ancestors of the Kwakwaka'wakw (Kwakwala-Speaking People) of today.

Eventually, some of the first ancestors wandered from the teachings sent down from above. Disrespect to the animals and the land was the most severe offence, and the Creator planned to fix this disrespect by sending a flood that would cover the earth and cleanse the world. The Creator recognized those ancients

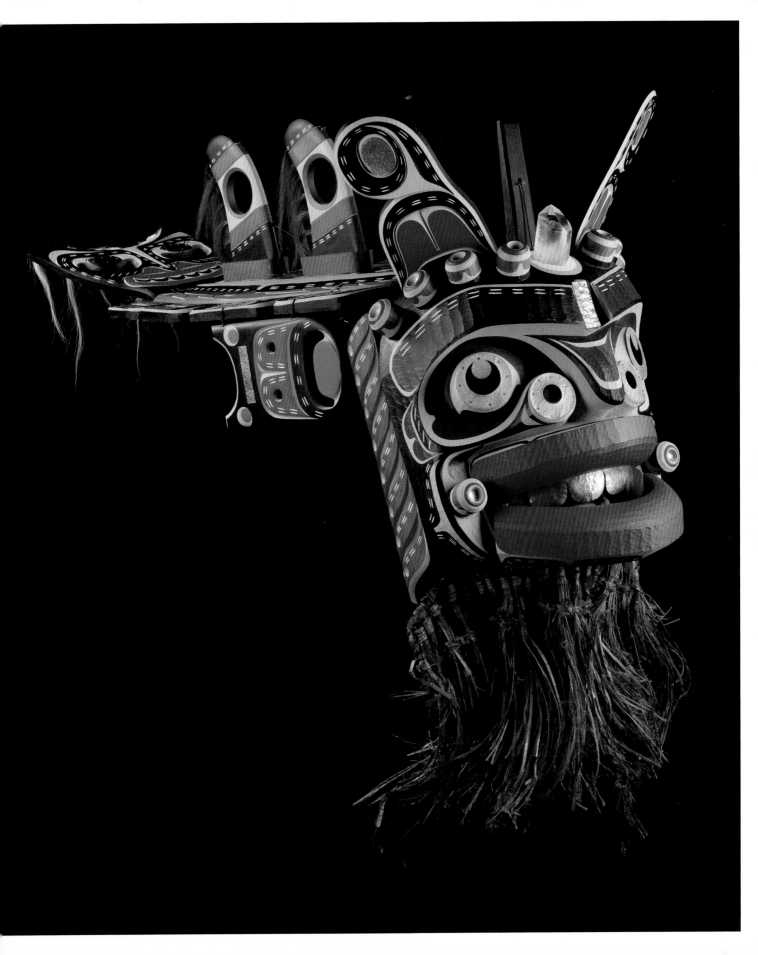

who followed His laws and would spare them by sending them warnings in dreams. Among these people was a man from the 'Namgis. This man was instructed to wait by the ocean and told that something would be sent to protect him. He was unsure but decided to believe and trust in his dream.

Soon the rains came and did not stop for many days. The tides quickly rose, and he was beginning to feel threatened and wanted to flee. When the water reached his neck, at his last moment of faith, the water level dropped, and from the ocean surfaced the enormous 'Namxi-yalegiyu. The man crawled onto its back and was so small in comparison that he seemed to disappear. This man was blessed with spiritual power and was able to breathe underwater and stay with the sea monster for the duration of the great flood.

When the flood ended and the water level dropped, 'Namxiyalegiyu returned this man to his home at the mouth of the Nimpkish River and vanished into the depths of the ocean, only to be seen on rare occasions. The man assumed the name 'Namukustolis, The Only One in the World. From that time on, the descendants of 'Namukustolis have used 'Namxiyalegiyu as a crest and re-enact this story through song and dance.

Tom asked me what I needed for our family's potlatch, and I told him a few items. He responded, "I don't want to do something ordinary for you, brother. I want it to be something incredible." I told him about the 'Namxiyalegiyu, and he wanted to carve this piece. When the mask was complete, I was in awe and could not believe the work he had put into it. I will always be grateful to my brother for his generosity and dedication to our culture; and his name from his paternal grandfather Chief Walawidi Thomas Harris Hunt is so fitting: "One from Whom Things Are Wished From."—William Wasden Jr.

Artist Biographies

RICHARD ADKINS 1955– | Richard Adkins was born in Prince Rupert, British Columbia. He has studied with Freda Diesing, Robert Davidson and Bill Reid. Known for overlapping layers of meticulously rendered designs that fuse many jewelry techniques, he is considered one of the elite jewelers of the Northwest Coast, and his work is featured in prominent collections internationally.

EUGENE ALFRED 1970– | Eugene Alfred was born in Mayo, Yukon Territory. He attended the Gitanmaax School of Northwest Coast Indian Art in Hazelton, British Columbia, where he studied with Ken Mowatt. He has completed numerous commissions for the Yukon, served as an ambassador of his culture internationally and participated in many exhibitions documenting excellence in Northwest Coast art.

WAYNE ALFRED 1958– | Wayne Alfred was born in Alert Bay, British Columbia. He began his career assisting Beau Dick with commissions for Expo 86 in Vancouver but later returned to Alert Bay to teach, assist with cultural initiatives and make art. A renowned dancer and participant at potlatches and ceremonies, he produces work with an innate understanding of history, performance, theatrical presence and the need to maintain a standard equal to the masters of past generations.

STAN BEVAN 1961– | Stan Bevan was born in Kitselas, near Terrace, British Columbia. He studied at the Gitanmaax School of Northwest Coast Indian Art and then completed an extensive apprenticeship with his uncle Dempsey Bob. An instructor and coordinator at the Freda Diesing School of Northwest Coast Art since its inception, he received the British Columbia Creative Achievement Award for First Nations' Art in 2011.

DEMPSEY BOB 1948- | Dempsey Bob, considered one of the foremost master artists of his generation, was born in Telegraph Creek, British Columbia. He has been a dedicated teacher throughout his career, including at the Freda Diesing School of Northwest Coast Art. He has attended numerous gatherings with international artists, and his own work is held in collections worldwide. He was one of the first recipients of the British Columbia Creative Lifetime Achievement Award for First Nations' Art.

JOE DAVID 1946- | Joe David was born at Opitsaht, on Meares Island, British Columbia, but moved with his family to Seattle, Washington. Drawn to the spiritual essence within art and culture, he has studied the practices of many other nations across North America and internationally and has participated in numerous cross-cultural gatherings. He is among the most respected master artists of the Northwest Coast, and his art is sought after by collectors worldwide. Known mostly for his graphics, wood sculpture and silver and bronze works, he was the first aboriginal artist in residence at the Pilchuck Glass School and continues to produce a few select glass pieces each year.

ROBERT DAVIDSON 1946- | Born in Hydaburg, Alaska, and raised in Masset, British Columbia, Robert Davidson is one of the most decorated Canadian artists today. He has received such prestigious awards as the Order of Canada, the Governor General's Award and lifetime achievement awards from the National Aboriginal Achievement Foundation and the B.C. government. His work spans all traditional media and has been featured in many solo exhibitions, including *Eagle of the Dawn* at the Vancouver Art Gallery, which showcased four decades of his artistic achievement. He is also dedicated to the preservation of Haida language, culture and ceremony.

CHUCK HEIT (YA YA) 1957- | Ya Ya was born in Hazelton, British Columbia, and comes from a family of notable artists. He apprenticed with his uncle Walter Harris and then enrolled in the Gitanmaax School of Northwest Coast Indian Art in Hazelton, where he taught upon graduation. He later worked with Robert Davidson. Ya Ya's work has appeared in many exhibitions, in Canada and the United States.

FRANCIS HORNE SR. 1952– | Francis Horne Sr. was born in Mount Vernon, Washington. Largely self-taught, he has earned a reputation for totem pole commissions, including five for the City of Totem Poles (Duncan, B.C.) as well as poles in Canada, the U.S. and around the world. His elaborate masks and highly detailed smaller works are limited in number but highly sought after.

LANI HOTCH 1956– | Lani Hotch was born in Klukwan, Alaska, and comes from a long line of Chilkat weavers. She began weaving under the guidance of her grandmother Jennie Warren, then learned from her tribal aunt Jenny Thlunaut and, finally, Cheryl Samuel. Inspired mostly by the natural environment in the Chilkat Valley and the weavings and the stories of her ancestors, she has completed several robes in the Ravenstail design.

RICHARD HUNT 1951– | Richard Hunt comes from a family of celebrated contemporary Northwest Coast artists. Elected to the Royal Canadian Academy of Arts, he was the first Northwest Coast artist to receive the Order of British Columbia and has also been awarded the British Columbia Creative Achievement Award for First Nations' Art, the Order of Canada and the Golden Jubilee Medal, among others. He contributes to numerous charities through an annual golf tournament in Victoria that bears his name.

SHAWN HUNT 1975– | Shawn Hunt is from Waglisla (Bella Bella), British Columbia. Born to a family of artists, he has a diploma in studio art from Capilano College and a BFA from the University of British Columbia, where he majored in sculpture and drawing. He apprenticed and still collaborates with his father, J. Bradley Hunt, on some carved wooden pieces, but he is known for his innovative carved jewelry and social commentary. His contemporary painting and sculpture have been featured in solo exhibitions, and he received the British Columbia Creative Achievement Award for First Nations' Art.

TOM HUNT 1964– | Tom Hunt was born in Victoria, British Columbia. He apprenticed with his father, Chief George Hunt, and then later worked with his brother George Hunt Jr. and his maternal grandfather, the late Sam Henderson. Dedicated to preserving family and tribal traditions, he is frequently called upon to make masks and regalia for ceremonies. In recent years he has produced numerous totem pole commissions as well as the longhouse at Klemtu, clan house posts for the school in Quatsino and a Welcome Figure for the Klemtu ferry terminal.

NORMAN JACKSON 1957– | Norman Jackson was born in Ketchikan, Alaska. He studied carving at the Gitanmaax School of Northwest Coast Indian Art in Hazelton, British Columbia, and metal engraving at the Totem Heritage Center in Ketchikan. Recognized as a master artist, he has apprenticed with Dempsey Bob and Phil Janze. His work is held in major collections, and he runs the Ketchikan's Carver at the Creek Gallery, which represents the work of Alaskan and Canadian First Nation artists.

WILLIAM KUHNLEY JR. 1967– | Bill Kuhnley was born in Seattle, Washington, but his family soon relocated to the western shore of Vancouver Island. He worked in his parents' cedar salvage business and in the bush for several years before beginning to carve seriously, first at the Duncan Heritage Centre in Duncan, British Columbia, and then as an apprentice to Robert Davidson. A gifted carver and designer, he is best known for meticulously detailed works that often combine carved and painted formline designs with sculpture.

JOHN MARSTON 1978– | John Marston was born in Ladysmith, British Columbia, into a family of carvers. He first apprenticed with Simon Charlie and then joined the artist-in-residence program at the Mungo Martin carving shed at the Royal British Columbia Museum. His work has been exhibited internationally, and he has received numerous commissions in Canada. He is a recipient of the British Columbia Creative Achievement Award for First Nations' Art.

LUKE MARSTON 1976– | Luke Marston was born in Ladysmith, British Columbia, into a family of carvers. He first worked with Simon Charlie and then, during five years at Thunderbird Park at the Royal British Columbia Museum, alongside Jonathan Henderson, Sean Whonnock, Sean Karpes and his brother, John Marston. He has exhibited internationally and has received commissions from the Canadian government. Recently he has studied jewelry design with repoussé master Valentin Yotkov.

KEN MCNEIL 1961– | Ken McNeil was born in Prince Rupert, British Columbia. He apprenticed with his uncle Dempsey Bob and now teaches at the Freda Diesing School of Northwest Coast Art. He has completed many commissions with Dempsey Bob, his cousin Stan Bevan and, more recently, with various students. He has contributed totem poles and painted house fronts for the Kitselas Canyon village reconstruction and the new cultural centre at Northwest Community College.

COREY MORAES 1970– | Corey Moraes was born in Seattle, Washington, and now resides in Vancouver, British Columbia. He did not grow up in a family of artists but learned his craft by researching old artworks in museums, galleries and books. Today, his work can be seen in those locations. His designs gained international recognition through the American Museum of Natural History travelling exhibition *Totems to Turquoise* and are now found in private collections in North America, England and Japan.

KEN MOWATT 1944– | Ken Mowatt was born in Hazelton, British Columbia. He studied, and later taught, at the Gitanmaax School of Northwest Coast Indian Art, with Earl Muldoe, Walter Harris and Vernon Stephens. He also learned jewelry making from Jack Leyland and watercolour painting from Ron Burleigh. A mentor and major influence for many artists, he is a prominent carver and graphic artist who has illustrated children's books. His work is included in the *Legacy* collection of the Royal British Columbia Museum and was featured in *Topographies* at the Vancouver Art Gallery.

MEGHANN O'BRIEN 1982– | Meghann O'Brien was born in Alert Bay, British Columbia. A former professional snowboarder, profiled in *Snowboard Canada Women's Annual*, she recently discovered a passion for weaving. Her teachers have included Kerry Dick and her mother, Sherry Dick; Donna Cranmer; and Victoria Edgars. She has now produced a range of pieces from fine, intricately woven baskets to Chilkat robes.

TIM PAUL 1950– | Tim Paul is from Esperanza Inlet, British Columbia. He was First Carver at the Royal British Columbia Museum, where he oversaw numerous commissions of totem poles for international sites, and he administered a Native education program for the Port Alberni School Board and Vancouver Island. His work is part of the *Legacy* and the *Out of the Mist: Treasures of the Nuu-chah-nulth Chiefs* collections of the Royal British Columbia Museum, and he is known for his strong environmental focus. In 2010 he received the British Columbia Creative Achievement Award for First Nations' Art.

SUSAN POINT 1952– | Susan Point is from Musqueam, British Columbia. Trained as a legal secretary, she began making limited-edition prints on her kitchen table and then took courses in silver, casting and carving, and she was the first Northwest Coast artist to work in glass. Known for large mixed-media sculptures, she

has completed many commissions, including works for the Smithsonian Institution's National Museum of the American Indian, the Vancouver 2010 Winter Olympics and numerous public institutions. Her designs have supported an annual fundraising run for hospital charities in Vancouver, and she has sat on the board of the Emily Carr University of Art + Design.

TERI ROFKAR 1956- | Teri Rofkar was born in San Rafael, California, and was raised in Alaska. Her family spent winters in Anchorage and summers in Pelican, a fishing village. She has lived in Sitka since 1976. She is known for her Tlingit spruce-root baskets, which combine Alaska's indigenous resources such as spruce root, maidenhair fern, cedar and grass with the traditional twining and plaiting weaving techniques of the Tlingit tribe. For her work she was awarded a National Endowment for the Arts (NEA) Heritage Fellowship, the highest award for traditional folk arts and crafts in the United States, and named a "living cultural treasure."

ISABEL RORICK 1955- | Isabel Rorick was born in Old Masset, British Columbia. She comes from a long line of weavers, including her mother, Primrose Adams; her aunt Delores Churchill; and cousins April and Holly Churchill. She began to weave seriously in 1982. Dedicated to having weaving considered a fine art form,

she has been included in many exhibitions showcasing new directions in Northwest Coast art. Her work is held in major museums and galleries across Canada and the United States and in Europe.

JAY SIMEON 1976- | Jay Simeon was born in Fort Macleod, Alberta. His art was inspired by his first cousin Sharon Hitchcock, who taught him the principles of Haida design. He then studied engraving under Dwayne Simeon and learned casting and repoussé techniques at Vancouver Community College. Today, he creates intricate works in argillite, precious metals, acrylics and wood, and he painted a Steinway piano that has been played by such master pianists as Lang Lang. His work has been included in numerous major exhibitions. In 2011 he received the British Columbia Creative Achievement Award for First Nations' Art.

PRESTON SINGLETARY 1963- | Preston Singletary was born in San Francisco, California. He studied at the Pilchuck Glass School, where he still teaches and sits on the board. The only aboriginal artist to train solely in glass, he apprenticed under many master glass artists, studied international glass techniques

in Sweden and Finland and now bridges glass blowing and Northwest Coast art. He has collaborated with such artists as Tammy Garcia, Lewis Gardiner and Joe David, and his solo work has been exhibited nationally and internationally.

KEITH WOLF SMARCH 1961– | Keith Wolf Smarch, known as Shakoon, lives in Teslin, Yukon. He was a student of Dempsey Bob and has studied woodcarving in Alaska, British Columbia and Japan. His masks, hats and frontlets are worn in ceremonies, and other work can be found in collections throughout North America, Europe and Japan. He was recently selected to oversee a village reconstruction in Carcross, Yukon.

HENRY SPECK 1937– | Henry Speck Jr. was born in Alert Bay, British Columbia, and is the son of Henry Speck, a renowned graphic artist. Largely self-taught, Henry Jr. began carving while working as a logger and was encouraged by his employer to concentrate on his art. He is considered one of the foremost carvers of the large cannibal bird masks used in ceremonies, and although he produces few pieces each year they are highly sought after for their intricacy and manoeuvrability.

NORMAN TAIT 1941–
LUCINDA TURNER 1958–
Norman Tait was born in Kincolith, British Columbia. Considered the foremost Nisga'a artist working in wood, precious metals and graphics, he has carved poles for the Field Museum in Chicago and Bushy Park in London as well as commissions across Greater Vancouver. He has taught and lectured extensively on Northwest Coast art. In 1991, Lucinda Turner began an apprenticeship with Norman Tait that has evolved into a successful working relationship in which they produce pieces collaboratively and independently.

GLENN TALLIO 1939– | Glenn Tallio was born in Bella Coola, British Columbia. Directly descended from hereditary chiefs, he is an accomplished airbrush painter and carver. Many of his pieces are commissioned for ceremonial purposes because of his deep understanding of Nuxalk traditions, though others, including the Nuxalk longhouse at the Canadian Museum of Civilization, are held in museums.

ART THOMPSON 1955–2003 | Art Thompson was born in Whyac, on Vancouver Island. His father and grandfather were both renowned artists, but he contracted tuberculosis and was hospitalized away from his family and then sent

to residential school in Port Alberni. Later he studied commercial art at Camosun College and began to work in paint and pastels. He is known for using strong contemporary and traditional design shapes, with a narrative approach to myth and legend. His cousin Martin MacNutt, born 1982, who contributed the beading on the cradle board, has been beading since the age of twelve.

CHRISTIAN WHITE 1962– | Christian White was born in Queen Charlotte City and raised in Old Masset, British Columbia. He started carving argillite under the direction of his father, Morris White, and then studied the work of the great masters, especially of his great-great-grandfather Charles Edenshaw. Supporting himself as an artist since age seventeen, he is known for narrative storytelling and a strong use of inlays. He has constructed a major longhouse in Masset, is a dedicated teacher and has been active in lobbying for the return of Haida artifacts.

WILLIAM WHITE 1960– | William White was born in Prince Rupert, British Columbia. He was given the hereditary house chief's name, Tsymiyaanbiin (Barnacles on the Belly of the Supernatural Being), in 2008 at a potlatch held for Marvin Wesley where he assumed his chiefly name, La'as. He is dedicated to the renaissance of weaving among his people and has travelled to many villages promoting the use of his pieces as regalia in traditional ceremonies and teaching traditional weaving. He has participated in international workshops, seminars and research projects dedicated to understanding and producing traditional woven pieces, and he wove a robe at the Museum of Anthropology at UBC that was part of an educational program and is now in the museum's permanent collection.

LYLE WILSON 1955– | Lyle Wilson is from near Kitamaat, British Columbia. He studied art education at the University of British Columbia and then printmaking at Emily Carr College of Art + Design. He has been an artist in residence at the Museum of Anthropology at the University of British Columbia, has held several solo exhibitions of his work and has produced major commissions in Vancouver and Osaka, Japan.